Stable Views

FOLKLORE STUDIES
IN A MULTICULTURAL
WORLD

The Folklore Studies in a Multicultural World series is a
collaborative venture of the University of Illinois Press, the
University Press of Mississippi, the University of Wisconsin
Press, and the American Folklore Society, made possible by
a generous grant from the Andrew W. Mellon Foundation.
The series emphasizes the interdisciplinary and international
nature of current folklore scholarship, documenting connec-
tions between communities and their cultural production.
Series volumes highlights aspects of folklore studies such as
world folk cultures, folk art and music, foodways, dance, Af-
rican American and ethnic studies, gender and queer studies,
and popular culture.

Stable Views

Stories and Voices from the Thoroughbred Racetrack

Ellen E. McHale

UNIVERSITY PRESS OF MISSISSIPPI • JACKSON

Publication of this book is supported by a grant from the
Andrew W. Mellon Foundation.

Designed by Peter D. Halverson

www.upress.state.ms.us

The University Press of Mississippi is a member of the
Association of American University Presses.

All photos by Ellen McHale, unless otherwise noted.

First printing 2015
∞
Library of Congress Cataloging-in-Publication Data available

British Library Cataloging-in-Publication Data available

To my husband John, with my appreciation for his unwavering support and encouragement.

Contents

Preface

This book is about the folklore and folklife of horse racing, focusing on the "backside" or "backstretch," the area of the thoroughbred racetrack that includes the stable areas, worker lodging, a kitchen or dining facility, and associated organizations and businesses. In many cases, the stable area referenced by the term lies away from the public areas of race viewing. It may be at the far end of the oval racetrack or it may be physically apart but connected to the racetrack by a road. For many who are addressed in this book, the backstretch comprises their place of work. For some, it also is their place of residence, as single-sex dormitories are often sprinkled throughout the stabling areas for horses. My interest in horse racing began as a chance encounter with Saratoga Springs and the racing community situated within New York State in 1996. This encounter began more than fifteen years of research in the backside of the thoroughbred racetrack, included hours of interviews and miles of walking, and received support from the New York State Council on the Arts and support in 2012 from the Archie Green Fellowships in Occupational Folk Culture from the Library of Congress.

My introduction to the racetrack and its world of racing began in 1996, as I was asked by the National Museum of Racing and Hall of Fame to conduct an ethnographic study of the "backside." At that time, the museum was searching for a way to interact with the wider racing community and to expand their audience beyond that of predominantly racing consumers. They were also interested in increasing their knowledge of the racing environment around the Saratoga racetrack, which could serve to inform their educational programs and their curatorial and exhibits program. My work was initially supported by the Folk Arts Program of the New York State Council on the Arts, which provided grant support for documentary fieldwork and for programming based on that fieldwork. This documentation, which began as ethnography in 1996, by 2003 had

become a festival based program that drew hundreds to Saratoga's racetrack each August.

Heretofore, much of the oral history that had been collected by the National Museum of Racing and Hall of Fame had centered on the public face of horse racing. As a documentary activity of the Hall of Fame, trainers, jockeys, and owners of celebrated horses had typically been interviewed for the archival collection of the Hall of Fame. This Hall of Fame oral history program provides a portrait of those who have made it to the top of the profession and whose fame is linked to sustained success over many seasons of racing. The stories of these three occupational roles comprise much of the contemporary literature of racing. Those who read and write about racing have tended to focus on the celebrated roles of jockey, owner, and winning horse (Case, Hillenbrand, Hotaling, McEvoy), with trainers providing a secondary focus (McGinnis).

I was asked by Field Horne, then-curator of the Racing Museum, to explore the many occupational roles within the backstretch and to document some of the many personalities and unique jobs one finds in this world. Over the next fifteen years I was guided by many individuals, who shared their experiences with me and recommended others. My most notable guides included Richard "Dick" Hamilton, a retired steward who opened many doors to me early in the project and who was always available to provide assistance with finding the right person. He provided entrée into the areas of the racetrack seldom seen—most notably, the judges' booth—and introductions to New York Racing Association officials. Recreation director Nick Carras chauffeured me around in a golf cart, taking me to stable areas of the Saratoga and Belmont racetracks and introducing me to key individuals. I am indebted to him for his introduction to several backstretch workers.

Early in my research, I was directed to several individuals, such as Louis Olah of the silk room and Tony Mangini who ran the backstretch "kitchens," because of these individuals' longevity within the Saratoga backstretch and for their insight into people and practices. They proved to be important historians for Saratoga and for the Saratoga racetrack as a unique place. Others, such as Ellen Loblenz and Dave and Lee Erb, provided in-depth portraits and individualized responses to the more generalized world of horse racing. Finally, individuals such as Ray Hovy were able to make explicit the generational connections that many individuals hold within the racing world and to elucidate the commitments that many have to racing and the people it supports.

This research benefited greatly from an Archie Green Research Fellowship in Occupational Folklore that I received from the Folklife Center of the Library of Congress in 2012/2013.

I am indebted to Nancy Groce and the staff of the American Folklife Center for their encouragement and moral and financial support. This support allowed me to visit several different racetracks, which provided a wider purview for my research and allowed me to interview several individuals during moments of relative calm during racing's off-season. Under the auspices of the Archie Green Fellowship, I was able to spend time at the Belmont Racetrack, the Evangeline Training Center in Lafayette, Louisiana, and the Palm Meadows Training Facility in Florida. True to Archie Green's vision of occupational folklore research, I was able to "learn about the diversity" of racetrack workers through speaking directly to the workers and to explore the relationship of specific ethnic groups to their experience of labor (Green 1978) I wish to thank the administrative staff of the training facilities—A.J. Credeur at Evangeline and John Hoffman at Palm Meadows—for allowing unconditional access to their facilities and their assistance in identifying and introducing me to trainers at their facilities.

Finally, I wish to acknowledge, with appreciation, the support of my family, especially my husband John, who encouraged me throughout this journey, and my children, who never ceased to ask me how my "book was coming along." I couldn't have done it without you. Thank you.

Stable Views

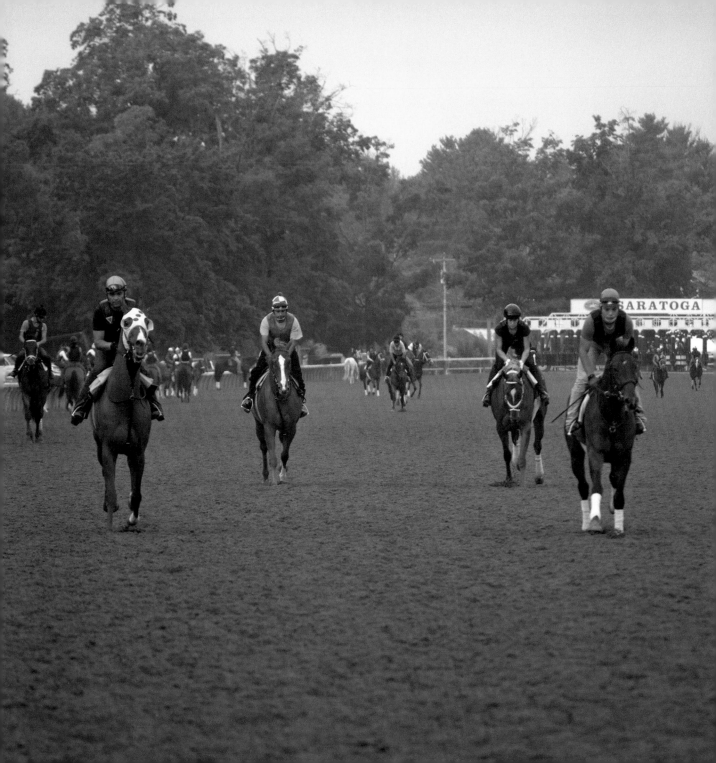

Chapter 1

The Shared Experience of American Horse Racing

Saratoga Springs has a long and distinguished history as a first-class resort. Already a destination in the mid-nineteenth century as a therapeutic spa, Saratoga Springs attracted many resortgoers throughout the eighteenth and nineteenth centuries, who travelled to this locale to take advantage of its healing waters. In 1826, as a response to anti-gambling and religious reformers, Saratoga Springs incorporated as an independent and separate village centered around the mineral springs and its resort businesses, allowing the village to control and protect its predominant commercial interest—the promotion of a tourist economy (Armstead 1999). Gambling, as an activity of leisure, became part of the milieu of this burgeoning resort city. A gambling house opened in 1842, and remained open throughout the nineteenth century in defiance of New York State anti-gambling legislation in 1851 and 1855 (Armstead 1999).

It was Irish-born boxer, gambling house owner, and entrepreneur John Morrisey, who first promoted horse racing within Saratoga Springs. In 1861 Morrisey moved his New York City establishment to Saratoga Springs and eased himself into spa society by contributing to local charities and benevolent associations. The city began its long love affair with horse racing in 1863. Ignoring the national conflict that was the Civil War, Morrisey proclaimed three days of horse racing at Saratoga with horses from Canada, New Jersey, Pennsylvania, and New York. Three days of racing was soon extended

Exercise riders during a morning workout Saratoga Racetrack, 2012. Photograph by Zach McKeeby.

into four days, as attendance and public interest warranted additional time to the meet. A New York–based horse racing association was formed that included several of the nation's prominent business leaders, including stock-broker William Travers and lawyer and financier Leonard Jerome, both of whom were active proponents of horse racing in the New York City area. The grandstand at the Saratoga Race Track (which is still in operation today), was built the following year (1864) and the first Saratoga Cup Stakes was held in 1865. Gambling, horse racing, and the attendant horse-race betting soon became the central draw for the village of Saratoga Springs, eclipsing the appeal of Saratoga's medicinal waters (Armstead 1999).

Saratoga's success of flat-track racing, in which thoroughbreds are raced with a seated rider, was seminal for the organization of the American Jockey Club by Leonard Jerome and other New York City racing supporters (Riess 2011). The grandstand and its newly constructed racecourse at Saratoga were considered the best in the country at the time, an opinion still expressed by many proud Saratoga residents and racing fans today. It retains the title of the oldest formal sports facility still operating in the United States (Riess 2011). From these beginnings, Saratoga became a world-class thoroughbred racetrack that supports a six-week season with ten races each day.

Horse racing had its original start in rural America and was firmly part of the American Colonies before the Revolutionary War. Horse racing was considered a "gentleman's sport"; to own and race an expensive thoroughbred was an emblem of wealth and status. To breed horses in pre-Revolutionary America was an expensive and risky venture. Nevertheless, in the southern United States, enormous sums of money were invested in racehorses as early as the eighteenth century by Southern planters (Sparks 1992). During the time of England's colonization of the American continent, mares and stallions of Arabian lineage were imported from England by gentlemen landowners to produce a better racehorse in America (Kupfer 1970). From its beginnings, those wealthy landowners involved in horse breeding and racing saw it as an extension of their privileged lifestyle, a way to gain social status, and to demonstrate their manliness (Riess 2011).

The first formal racecourse was laid out in Hempstead, Long Island, New York, in 1664, owing to New York's early status as the center for horse racing in the North. In the South, Virginia dominated the sport, as horse racing appealed to large colonial landowners who wished to approximate the lifestyle of the English country squire. Southern gentlemen planters used the contests to demonstrate their status as gentry, employing the rituals of racing and betting to indicate their superior social

status (Riess 2011, 2). Early racing in the eighteenth century took place down thoroughfares and on public roadways. When conditions became too dangerous for pedestrians and other vehicular traffic, city officials in several localities began to advocate for the laying out of designated racecourses. In that way, early quarter-mile dashes down dirt roads gave way to an oval track that was roughly one mile in diameter.

Although it was primarily a rural sport, horse races at southern capitals such as Charles Town, South Carolina, and Williamsburg, Virginia, were social events of the year. By the mid-eighteenth century, the sport of horse racing was included in upper-class social calendars, and elite jockey clubs made up of horse racing's gentry had been established to operate enclosed racetracks where thoroughbreds competed (Riess 2011).

Horse racing in the seventeenth and eighteenth centuries was often included as an activity of other, larger events. Market fairs, similar to European agricultural fairs, were held in Colonial America. Along with the sale and exchange of agricultural products, these events included horse racing, troupes of travelling showmen, acrobats, vendors, gamblers, thieves, and fortune-tellers. As commercial enterprises, these agricultural marketplaces did not sustain themselves in America. By the early 1800s, the format of the agricultural fair became one of educational enterprise rather than commercial market. Horse racing was dropped from this format, especially in the North, as it did not conform to the educational and presentational model for the agricultural fair being espoused by the social reformers of the time. Horse racing was reintroduced, however, in the form of harness racing. By the late 1840s, fair programs included the sporting pastime of racing trotters (Kniffen 1949).

A festive atmosphere was often present at horse racing, with games of chance, fortune-telling, and glittering balls and other formal occasions catering to the social elite. The importance of horse races was not lost on the politically astute. Historian Randy Sparks writes of the importance of horse races at Charleston, South Carolina, where states' political meetings were timed to correspond to the event. In the pre–Civil War South, horse racing was found at courses in Alabama, Louisiana, Virginia, Mississippi, Tennessee, Kentucky, and South Carolina. While women were generally discouraged from attending other gambling events such as card playing, in the South they were encouraged to attend horse races due to racing's reputation as a social occasion for elite landowners (Sparks 1992). In the reformist North, however, women were discouraged from attending, as horse races were considered too rowdy and likely to incite fighting. This trend of discouraging women from attending

began to change with the building of New York City's fashionable Jerome Park in 1866, which was built to appeal both to women and to the working classes and had separate entrances and seating for "ladies" (Riess 2011).

The Civil War disrupted the sport in the South, as the trials of war did not allow its continuation. However, it did not come to a complete halt; racing continued in the Northern states of New York, New Jersey, Maryland, and Delaware. These northern states gradually pronounced their control over the sport (Veitch 2004), control that was cemented through the inauguration of the New York Jockey Club in 1894. After a struggle over which state's horsemen, Kentucky's or New York's, would be the owner and maintainer of a nationwide stud book to keep track of horse lineages, New York's Jockey Club became the victor. Prior to this time, horsemen could choose to register with the *American Stud Book*, maintained by Kentucky horsemen Benjamin and Sanders Bruce, or the Jockey Club's Registry, located in New York State. The Jockey Club's purchase of the *American Stud Book* for $35,000 meant that New York's Jockey Club became the most powerful regulator of horse racing in the United States. No horse in the United States could be recognized as a thoroughbred unless the Jockey Club accepted it (Wall 2010).

One of the earliest forms that horse racing took was the match race, in which one horse was pitted against another in a race to see which owner had the most splendid animal. Match races often took place at the local level and could incite local and regional rivalries. Match races could also command nationwide attention. One of the most noted match races took place in 1823, with the undefeated "Northern" horse, American Eclipse, competing against the "Southern" Sir Henry. This contest, held on New York's Long Island, was attended by then-Senator Andrew Jackson, as well as 20,000 other horse racing enthusiasts. Historian Steven Riess writes, "The Eclipse-Sir Henry race provided a safe, nonaggressive outlet for mounting regional rivalries" (Riess 2011).

Stakes races, another racing format, are run on a specified date in which each entrant pays fees to enter and the field of competition includes several horses. The "purse," or winnings, includes these fees plus an amount of money provided by the racetrack (Alfange n.d.). Even after stakes races became the norm, match races against two or three horses continued in the United States, especially in the most rural areas of the country. In the rural parishes of Cajun Louisiana, match races persisted well into the twentieth century and many contemporary jockeys and riders got their starts as young boys competing in local match races.

Louisiana trainer Oran Trahan has been training horses for over forty years, as did his

father before him. He describes how horses and horse racing were a large part of rural, agricultural life in Louisiana:

Racing is so much of the culture here. Oh yeah. Horses are so big. And not only racehorses but horses in Louisiana are big, you know. I don't know why. Louisiana people are basically rural. The people who settled Louisiana, even North Louisiana, they were farmers. And I guess that probably has a connection because if you were rural a hundred years ago, fifty years ago, you had to have horses and mules to survive. . . . My dad had horses. He was a farmer. He had horses and mule and on weekend the horses were used for racing. They would "match" them. And this was part of the culture and it was BIG. People didn't have much to do other than that. But this was part of our culture, I remember my dad saying. . . . It was a public road but it was a dirt road, that's how things were. And there was very little traffic sixty years ago. So they fenced part of the public road to have their races. I guess they had a lot of fun.[1]

These races were community events that pitted individual horses against each other. Planning for a match race would begin early in a week, with entrants declaring their interest.

The matches would then be publicized for wagering. Horse races in twentieth-century rural Louisiana were accompanied by barbecues and beer. Horse owners would enlist local youth as riders. In this French-speaking part of Louisiana, youth would receive little compensation for their breakneck rides down a country road, or later around small racetracks such as Evangeline Downs in Lafayette, Louisiana. Cleveland Johnson recalls that he received five dollars for riding match races as a boy in the 1960s. Born and raised in Rayne, Louisiana, Johnson left Louisiana after high school and found work with Boston-based trainer Butch Lenzini. Johnson now stables his horses at Aqueduct Racetrack in New York, and is one of the few trainers of color in horse racing.

In an interview in 2012, A.J. (Alphonse James) Credeur described the interest in match races that predominated the area during his childhood. In 1972 Credeur started training and riding quarter horses owned by his father. At the time, he was only twelve years old. Around 1976 his family began to train thoroughbred horses instead. Today, Credeur serves as manager for the Evangeline Training Center in Lafayette.

Our [Cajun] heritage is dying because we had bush[2] tracks here. We had all these little bush tracks here and these kids would start riding when they were young.

Like when I was twelve years old. Like, I mean, we all rode young. Some stayed small, some got big [laughs]. The career ended when you put too much weight on. But I think that's where our good riders came from was the ones that started out at a young age at these bush tracks. If they continued on for the next five, six years by the time they're old enough to get a license. Even then, some of these riders, they were falsifying their birth certificates to where they could get a license to ride. I know a couple of them that rode when they were fourteen years old who were riding at a recognized track. But they'd falsified their birth certificates to be able to get their license. They made good riders, extremely good riders. Ronald Ardoin[3] is another one who won a lot of, a lot of races. And I think that just everybody back here—little sharecropper farmers—just about all of them had a race horse. They had something to do on Sunday afternoons. They'd have a supper maybe, like on a Friday night. They'd have a supper at a little a bush track and that's where they made all their match races and then come Sunday afternoon they went to the races. And it was a family thing. They whole family was there. Kids were running around playing in the dirt, playing marbles. I remember that like it was yesterday. We played marbles in the dirt. Lord have mercy! We looked forward to that on Sundays.[4]

In Southern Louisiana, small racetracks proliferated. Cleveland Johnson who was born and spent his childhood in nearby Rayne says of this area: "Back in them days we had four or five tracks, between a thirty-five- and fifty-mile radius. It's in your blood and that's it. It's tough to get away from and that's about it."[5]

This density of small, locally owned racetracks created an atmosphere where riders polished their craft. The list of successful riders is long.

Louisiana has produced a lot of quality Hall of Fame riders. Jockeys . . . Eddie Delahoussaye,[6] Pat Day[7] was here in Louisiana, Mark Guidry.[8] Kent Desormeaux,[9] Rob Alborado,[10] Shane Sellers[11]—all top-notch riders that left from here and went up North and did extremely well.[12]

As a kid back home, being from that part of the country, we race a lot of horse. The match races on Saturday and Sundays. That's like I started. . . . Back when you are small, you got to earn money during the summer. So I was riding horses from the age of eight. That's when I started. I'm sixty-one years old now. That's a long time.

So after high school in 1970. (I left home after I graduated in 1970) and I landed in Boston. That's when I met Butch Lenzini in Boston. I started out as a groom. . . . As a kid growing up that's what I wanted to do. I wanted to be a trainer.[13]

For Cajun horsemen in Louisiana, horse racing is part of the everyday landscape. Horse racing becomes the backdrop for community sociability and is situated in a specific geographic and cultural milieu.

In situating the racetrack as specific space and place, it is useful to reflect on the work of geographer Yi-Fu Tuan. In speaking of modern society, Tuan speaks about the complex nature of modern nomadic life and the complicated relationship between mobility and a sense of place. For Tuan, the nomad's world consists of places connected by a path. In time, the sense of place extends beyond individual localities to a region defined by these localities (Tuan 1977). Similarly, for those involved within the racetrack world, the place of the backside is realized through the racetrackers' customary pattern of movement. In effect, horsemen are modern nomads travelling from racetrack to racetrack. For those who compete within the East Coast, one's pathway to place may be Saratoga, Belmont, and Florida in an annual cycle of race meets. For many involved in competitive racing at a more local level, the pathways may be regional in nature, as illustrated by the circuit from Louisiana Downs to neighboring Texas and back again, or from Florida to Virginia in a continual back and forth. Other circuits of movement may include Kentucky, Maryland, and any other combination of the myriad racetracks found within the United States. Trainers often locate their "home" in a specific racetrack such as New York City's Belmont Racetrack, or Keeneland in Lexington, Kentucky, but will spend much of the annual cycle of racing away from this home. Training centers, such as Evangeline Training Center in Louisiana or Palm Meadows in Florida, are built specifically for conditioning and schooling thoroughbred racehorses and are not attached to any specific racetrack. Located in the American South, they offer a mild climate for training during the winter months.

For much of the racetrack community in the United States, a sense of belonging is constituted through the shared occupational setting; the reliance on structures of customary behavior, shared vocabularies, and patterns of ritual; and the knowledge of participating in a unique and historical tradition of work and sport. One gets to know this place of the backstretch through listening to the cadence of speech, the rhythm of the work, and the regimentation of each day. Using ethnographic methodology, I interviewed dozens of individuals who make their livelihood working with some aspect of

thoroughbred horse racing, and spent hours observing workers within the backstretch, mostly in Saratoga Springs but also at Belmont in New York and Tampa Bay Downs in Florida. My observations were not as a participant/ observer, as I did not enter into employment within the racing environment. Rather, I am relying on hours of interviews I conducted over several years with trainers, jockeys, exercise riders, and grooms.

The backstretch is an unforgiving place and its occupants, both equine and human, demand time and conformity. This was made clear to me as I watched an exercise rider berate another person for riding his bicycle toward him at the end of the morning workout session. The intersection of training track and stable area is a danger zone at any racetrack. Horses are entering and exiting an oval enclosed by a fence and may be skittish from the increased movements of riders and horses, excited by the release from a night spent at the barn, or hungrily anticipating the meal of grain awaiting them at the barn. Any unexpected movement or item out of place can cause a sudden reaction that can cause a rider to lose his mount, a horse to slip and fall, or any number of other calamities. In this instance, the cyclist was at the end of his work day and was heading home on his bicycle. His traversing that boundary between training track and stables, and his crossing through the path toward the training facility, caused a momentary disruption of the normal flow of horses to track and back again. The seated rider, on his way to the barn, was not yet finished with his work day and was momentarily endangered by the cyclist's movement across the horse path. This untoward juxtaposition of leisure and work and the unexpected break in routine sparked the exercise rider's outburst and verbal harangue of the bicyclist.

Always concerned with my own presence being a break in conformity and thereby causing someone's bodily injury, I was sobered by what appeared to be, to my uninformed eyes, a benign encounter. On another occasion, I was the subject of correction as I knelt on the grass and fumbled for a camera lens on the grassy space near the training oval track. A seated rider approached me and instructed me to remain standing as my crouched stature approximated a "predator" for his horse. Experiences in the backstretch are intense.

Attachment to the "place" comes with mastery and familiarity. As geographer Yi-Fu Tuan remarks, "attachment is seldom acquired in passing." The newcomer entering the backstretch for the first time is unsure how to act, where to stand. Horses are nearsighted by nature, and the newcomer must enter into the perceptual realm of the horse and be aware that sudden movements or unexpected occurrences can cause a chain reaction of events

when a horse reacts. Only after becoming familiar with the ways of moving through the space that is the backstretch can one feel comfortable in these surroundings. Attachment takes time for workers and visitors alike. For some, attachment comes through generational involvement in horse racing. For others, attachment is precipitated through youthful enthusiasm for horses that deepens through learning on the job as hot-walker or groom.

The backstretch is an intimate space and its enclosures are not only physically constructed, as relationships between individuals create a web of connection. The architecture also hints at the social nature of the backside. The shedrow is largely open and the stable activities conducted in full view of passers-by. However, to enter a stable area, one must be invited in. That invitation comes reluctantly if one is not known to the backstretch community. The backstretch is so well guarded by its inhabitants that to move around freely necessitates a guide, or at least a prior introduction. Borrowing from Tuan, this intimate space becomes a "hometown," which is lacking in glamour and architectural distinction. And as with Tuan's intimacy of home, an outsider's criticism is resented (Tuan 1977, 145). Horsemen are wary of ongoing scrutiny through media exposure and public outcry regarding unsavory training practices, undocumented backstretch workers, and perceived mistreatment of horses.

Eschewing exposure, the intimacy that is involved in horse care becomes difficult to express and make public.

Specific races such as the Churchill Downs' Kentucky Derby or Saratoga's Travers Stakes can be referenced as "races to watch." Specific locations and racetracks can also be identified as the tracks "every horse racing fan should visit." Across the industry, however, that unique bounded space that constitutes the backstretch of the thoroughbred racetrack engenders feelings of loyalty and a sense of belonging. No matter in which backstretch one finds oneself, the social alliances created there generate a shared sense of place.

Chapter 2

A Day in the Life of the Backstretch

Whether working in the stable areas of Belmont Racetrack in New York City or Tampa Bay Downs in Florida, thoroughbred racetrack workers can easily adapt to the rhythms of work because of their shared occupational folklore. When a backstretch worker enters the backstretch, he or she will already have information regarding a shared vocabulary, a way of work, and the common courtesies that are expected to be followed in order to maintain the safety of all in the backstretch. Archie Green, who devoted his life to the study of workers' lives in the United States, characterizes this "labor lore" as encompassing "job technique, customary practice, verbal art, and ideological cause" (Green 1993, 20). Green challenges us to "put this key term to work with close analysis of particular texts and acts, as well as comprehensive overviews" (Green 1993, 31). This volume on the working world of the thoroughbred racetrack follows Archie Green's lead and provides a comprehensive overview of an often overlooked and misunderstood occupational setting.

The occupational world of the racetrack is dictated by a training regimen designed to ready a racehorse for competition. The care of the racehorse—and the horse's abilities to win races and thereby provide remuneration for its owner and workers—drives the working environment of the backstretch. All activity hinges on the horse and each day is a routinized and ritualized series of activities revolving around this animal. Carole Case, in her work *Down*

Groom with horse in the paddock parade, Tampa Bay Downs, Florida, February 2013.

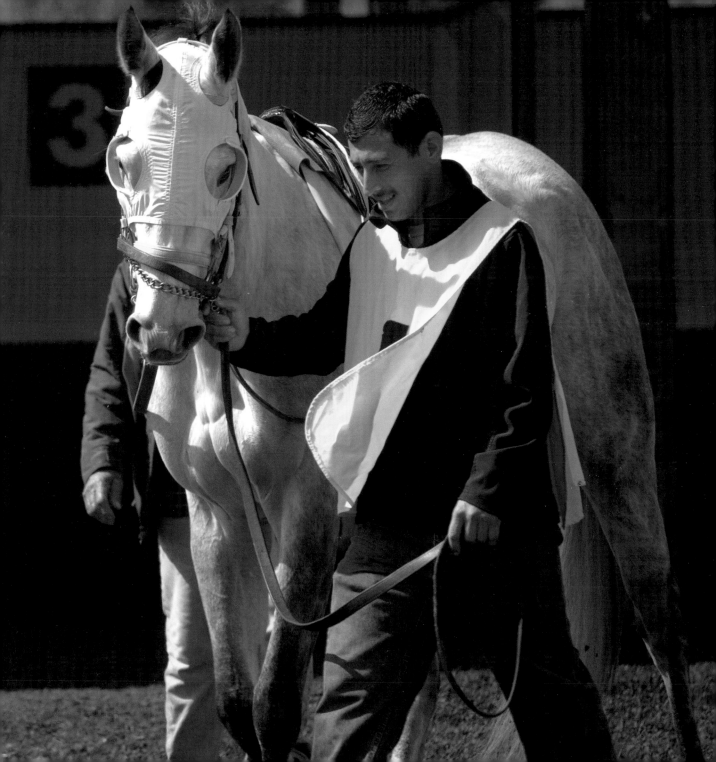

the Backstretch (Case 1991), describes a typical day within the backstretch. She speaks about the informal patterns of exchange that secure friendships and foster reciprocity. She has also documented the daily routine as a "track ritual" designed to effect a positive outcome for the horse's performance during a race (Case 1991, 98).

The daily routine within the stable area of the thoroughbred racetrack indicates the workers' attempt to wrest control over an unpredictable activity: to make a racehorse run to its full potential. The groom is the first individual with whom a racehorse interacts each morning. The groom has several horses in his or her care and is the person who carries out the day to day care of a racehorse: bathing, applying bandages to sore legs, cleaning or "mucking out" a horse's stall, caring for their coats with curry brushes and combs, and making sure they have food and water. The groom works closely with an assistant trainer or trainer to follow the trainer's instructions.

I come in about 4:30. Feed breakfast. Most people have watchers[1] when they feed breakfast. We don't because the stable's not that big. But I come in about 4:30. Feed. Muck out my stalls. Then about 5:30–6:00 we start training. You know, we pack them up and send them to the track. They come back, we bathe them. But that lasts *until 10:00 or 10:30. Then we do them up. We put all kinds of liniments and poultices on them and put bandages on them. We feed about 11:00 a.m. . . . Then we come back about 3:30. . . . Muck out the stalls again and feed them about 5:00. And then we're done.*

It's a long day. We do get a little bit of time off but you can't do a lot. Not really. We're usually gone by 12:00 and you have to clean up. . . .

We both come in every morning. I rub three and he [Jerry] rubs three and the hot walker, he's rubbing the pony. That's good . . . we come back every other afternoon. . . . [The mornings], that would be too tough to do for one person. But it's not bad, every other afternoon. And sometimes we swap afternoons or I pay him to come back for me. Something like that.[2]

By 6:00–6:30 a.m., the exercise riders have begun the horses' daily workouts. The morning workout is a crucial activity, as it is the exercise riders' job to give the horse the sole exercise that it will receive in a day, and to provide observations to the trainer on the mood and fitness of the horse. He or she will let the trainer know if the horse is "off," an indication that there might be a hidden physical ailment. In fact, one former jockey and wife of a trainer stated that the riders are the most important

people to gauge the fitness of the horse.[3] It is the exercise rider who implements the exercise regimen prescribed by the trainer and who often comments to the trainer regarding the horse's ability to participate in the exercise regimen and whether or not he or she sensed any difficulties on the part of the horse.

Exercise riders occupy a unique occupational niche at the racetrack. Typically an exercise rider works as an independent agent, riding for a handful of trainers within a year's time. It is an early morning job that begins around 4:15 a.m. and is over by 10:30 a.m. The morning workouts are scheduled for the specific period of time when the track training facility is open, roughly from 6:00 a.m. until 10:00 a.m. Many riders are paid by the mount and work as freelancers or contractual riders. Others, especially those who ride for trainers with large numbers of horses, may ride for only one or a few trainers on salary. Ellen Loblenz is one such rider. Based in Saratoga Springs when I interviewed her in 1998, Loblenz worked specifically for one trainer during the Saratoga racing season.

You get to get on the same horses every day. You find that as a salary rider you get on the nicer horses while as a freelance rider gets on the horses that no one else wants to get on. You really get to spend time with them as a salary rider. . . . You

don't have to worry about what you're going to get paid at the end of the week. You know exactly what you're going to get paid. As a salary rider you get out and try to do the best job that you can do with the limited amount of time that you have. So I just prefer being a salary rider.[4]

Those who have a contract with a specific trainer, either as a freelancer or as a salaried rider, are felt to receive the better mounts. The regular rider has specific horses they train. Therefore, they are able to better know the animal's habits and can better gauge how the horse will respond to other horses or to sudden changes in routine. Cautionary tales abound regarding accidents that happen when one is put on an unfamiliar mount. Experienced rider Calvin Kaintuck has had his share of different horses. Calvin began riding as a young man in Baltimore, and continued to ride in the early morning hours through his years of education and even while working during the daytime hours as an electrical engineer for Westinghouse. Today, as an octogenarian, he continues to ride specifically for one only trainer. Like most experienced exercise riders, Calvin Kaintuck had his own cautionary narratives:

Another time, I'll never forget the date, 1967. I was in Delaware Park and one Sunday morning my buddy said to me,

"Calvin, I'm going to go home through the week. Will you cover for me?" And he had all these horses to get on . . . I had twenty-one horses to get that morning. So the first horse of his that I went down to, to get on . . . He said to me, "I'm not quite ready yet." So I looked round next to him. [Another trainer] said to me, "Calvin, won't you get on a horse for me?" So [the first trainer] says, "Calvin go on and get on his horse and by the time you get back you can get mine." But he didn't realize I got all my people waiting too. So, I got on this horse . . . she was sore going out. . . . Well I was going to turn around and take her back but I knew I'd gone this far. I was going to go right along. . . . So I was going up the backside at kind of a fast clip and she fell. And when she fell all I could see is . . . feet going over and I kept rolling. But I dislocated this shoulder, see this bone here— it's still like that. And that put me out of action. That was in June and I didn't get back to work until the fall of that year.[5]

When a rider arrives in the barn for morning workouts, he or she receives a "set list," which is the schedule for the day's riding and the order in which she'll exercise which horse. Depending on the training and the training regimen, riders will go out in pairs or in groups of riders. Lorna Chavez is a career rider who got her start riding in England but is an experienced rider in the northeastern United States. She explained the routine during a 2012 interview:

I normally get on between ten and eleven horses in a morning. But when they breeze,[6] they do a fast training . . . then the next day I walk. I had three of those yesterday so they're walking today. . . . I go in when the horses are tacked up. The grooms take care of the horses and put the tack on. I freelance, I'm not a salaried rider, so I'll do my set list[7] the night before and then I give them allotted times for what time I'll be there. So, I go from barn to barn to get on horses. I just get on them. I exercise them and bring them back. I take the tack off and just put it aside. And then they [the grooms] bathe them.[8]

In the morning, riding takes place for several hours, as each horse is run through its paces. Untried horses—two-year-olds who have not yet raced—are "schooled" or instructed during this period. They may be taken to the track and "ponied"[9] during a morning workout or they could practice entering or leaving the starting gate, as they would during a race meet. Again, there is a routine to this work:

Most of the time when you come in . . . each trainer has their own routine. But

what Cindy does, she has all the grooms line their horses up and she goes through and checks the horses' legs. She has people put the bandages on and then she has riders go out and walk around the barn until she's ready. Then they walk out to the track, they stand, and she gives them instructions.

What [a second trainer] will do is have the exercise riders get on the horses and then walk the horses around. Then he'll have them jog on the road. When you're on the pavement, if there is something about them, it magnifies it.[10] And then he'll tell you what you're going to do with the horse.[11]

The thoroughbred horse trainer has the task of preparing a horse for a successful race outcome and for oversight of all the individuals working toward that common goal. Trainers have a set routine for their work, and the training regimen can vary by trainer. Trainers are careful not to share specifics for their success. While trainers often share the same stable area and will interact collegially during morning workouts, specific training methodologies are not freely discussed. Training is like cooking. While there are several different ways to cook a specific dish, the cook is sometimes loath to provide the specifics. Lorna Chavez explains:

Most people jog horses for a while to loosen up their muscles. And they they'll generally gallop them a mile and a half. It all depends on your schedule. If they were just breezed the day before they will walk the next day or have a very light day and then the next couple of days it'll be light and then they'll start adding on distance to get their wind up. And then they'll give them an easy day before a breeze. And then generally it all depends on the horse but there is an eight to ten day cycle.[12]

Each morning's workouts are also part of the daily performance in the backstretch. Riders go out in "sets" from each trainer's stables, a set being comprised of a group of riders who enter the training track together. Trainers superintend these sets in various ways. One trainer will view each horse as it leaves the stable, as a parade judge views a float in a holiday parade; another trainer will accompany his group of riders to the track, where they will be lined up for last-minute instructions before putting their respective horses through their paces. While this routine is part of the training regimen, it also provides opportunities for multiple sets of eyes to view the horses in training: the diners in the grandstand who are enjoying a trackside breakfast; the owner who is visiting the stables this morning with family and friends in anticipation of that afternoon's

races; the clocking judge who is timing a horse's specific workout; and the other trainers who are sizing up their competition.

After riding, the horse is taken back to the barn and walked by the hot walker until his body temperature is cooled down after exercising. He will be bathed, rubbed down, and returned to the stall. Case has this to say about walking as an activity: "The proper way to perform the routine includes many specific imperatives. One must maintain a certain pace. One must keep a certain tension on the chain. One must keep one's arm at a certain level. One must maintain a certain distance from other horses and walkers. One must walk in a certain direction. These are just a few of the intricacies of walking. By following these prescriptions, walking takes on the character of ritual" (Case 1991, 97–98). Case's use of ritual follows folklore's idea of secular ritual as patterned, repetitive behavior that is believed to be efficacious.

Walking is the job of the hot-walker, who uses the interior of the barn, its shedrow, to walk the horse in a counterclockwise manner after it has run. As is the case for any athlete, walking is a cooling-down activity for the racehorse; during the morning workout period there could be as many as six horses walking, spaced at never-changing intervals, through the stable area of the barn. The hot-walker is the least skilled at the racetrack and is the most entry-level position. Besides walking, the

hot-walker will hold the horse's lead line while it is being shod and while it is being bathed. The job of hot-walker is routinely the place of a worker's first exposure to the backstretch of the racetrack. This role is believed to be less skilled than that of a groom, who is responsible for the direct care of one or several horses, including bandaging, grooming, and the administration of food.

The backstretch community shares the goal of conditioning and preparing thoroughbred racehorses to run races, and many of its inhabitants can point to years of involvement from many different angles. Many trainers and officials state that they began their careers at the thoroughbred racetrack by "walking the hots," many as teenagers as young as twelve and thirteen years old. John Hoffman, general manager of Palm Meadows, began walking hots while a teenager in Canandaigua, New York; Calvin Kaintuck started walking hots as a boy in Baltimore, earning twenty-five cents to walk racehorses. From that unskilled position, one can move into the position of groom. This position requires more experience with horses, as the groom is integrally involved with the horse's training regimen and care. From the position of groom one can become the stable foreman, who oversees all of the grooms and makes sure that everyone is working to their potential. The next ladder rung in the hierarchy is assistant trainer, a position of authority, especially in

the areas of personnel hiring and firing. With larger stables, the assistant trainer can be in charge of an entire stable in the absence of the trainer, who may be headquartered elsewhere. The assistant trainer position can be a springboard for the more prestigious post of trainer. However, the job of assistant trainer can also be the final destination, as a move into the more elevated position of trainer requires mentoring and the intervention of a sympathetic owner or trainer. In order to be a trainer, one has to have horses to train, and the lack of horses is a major stumbling block for the aspiring trainer. Both assistant trainer and trainer have to take a certification exam, which requires employment references.

> *Hot walkers is as low as you can go. Up from there is the grooms. The assistant trainers. You've got hot walkers the lowest, then the grooms, then the gallop people,[13] then assistant trainers, than the trainers.[14] When you start, you start as a hot walker. So you just cool the horses out. You just walk them around. They hold them for a bath. They pick up the bandages and put them in the washer or hang them out to dry. And clean out the wash tubs, feed tubs. That's how you start. Then you progress to a groom. Then you look after your horse. You tack it up and just brush it and . . . look after it.[15]*

The early morning is the period when the trainer is most accessible, overseeing the training regimen and observing the horses "at the rail." It is also the period when jockey agents line up mounts for their jockeys. It is not unusual to see jockeys and their agents going from barn to barn securing jobs for the next day's races. While everyone is able to connect via mobile phones, in the early morning hours people traverse the backstretch to personally make contact with each other. Trainers habitually gather at the rail to watch their horses in their morning workouts (and to observe the potential competition), and those running a horse in that day's races will use this opportunity to provide instructions to the jockeys. Owners who wish to observe their horses are also in evidence during this early morning period, and it is not uncommon to see trainers providing insights on the horses to their client owners.

During the morning workout period others begin to arrive, eager to speak to the trainer, assistant trainer, or barn foreman. The sales personnel for feed, shoes, and medicines are arriving in the pre-dawn hours, as are the farriers who will fit each horse entered in the day's races with new shoes. By the time of the first break in the training regimen at about 8:30, the stable area of any racetrack is busy with many people attending to their morning regimens. There is a congenial atmosphere within the

backside, as people comment on the previous day's races, the prior evening's post-race festivities, or greet each other in passing. At the mid-morning break, during which the track surface is groomed by large tractors dragging harrows, exercise riders and trainers take a short break in the assembly-line movement of horses to the track, purchasing a quick meal or cup of coffee at one of the many food trucks that circulate throughout the backside or socializing with fellow backstretch personnel.

The workday typically ends at 11:00 a.m, with the training facilities closing around 10:30 and the stable workers putting the last of the tack away and feeding the last horse by 11:00. The morning routine is slightly altered if a horse is preparing for that day's race. If a horse is entered in that day's race, the groom is required to remain with the horse. On a race day, stable workers such as the groom will stay in the stable area to wait for the races to begin and to accompany the horse to the track for the race. For many grooms, there is the feeling of pride for the part they play in the success of a horse during the races.

Besides the caretaking roles in the stables, there are many more specialized jobs and precise work roles that one may assume within the racetrack environment. There is the clocker, who records the unofficial workout times for the horses going through their morning paces; the gap attendant, who monitors the entrances and exits onto the racetrack and also records information regarding the horses' workouts; and the "outrider" and "pony person," who assist the thoroughbred and its human rider. Robert Paterno is a "pony person,"[16] that individual who escorts a racehorse to the starting gate before a race and who retrieves the horse and his rider after the race is concluded. At some racetracks, the pony person also escorts the racehorse from the stable area to the grandstand and racing paddock. The pony person helps calm the horse before the race, retains the order of horses in the moments leading up to the race during the "post parade,"[17] and assists the jockey before and after the race. Paterno began working at the racetrack as a groom. At various times he "galloped" horses and also trained thoroughbreds. Today, he works as a pony person, largely circulating from Virginia to Florida with his horses.

Bridging the backstretch environment with the "front" of the track that is frequented by the general public are the judges and racetrack officials at work before and during an actual race. These include the paddock judge, the finish judge, and the steward. Within the offices of the racetrack, a racing secretary decides the conditions for each race and creates the racing program for the race meet. Borrowing from Fine (1996), backstretch workers may employ more than one "rhetorical stance," or role, within a workday. The rider who "gallops"

in the morning, putting the horses through their paces in the early morning hours, may reappear later in the day to serve as a bug boy (an apprentice jockey) or a pony person, leading or "ponying" the horses to the starting gate for the actual race. Grooms can also be found within the "frontside" of the racetrack, parking cars for the public or serving as ushers and ticket takers in the grandstands of racetracks. For those in the lowest-paid jobs of hot-walker and groom, multiple roles assist with making a living.

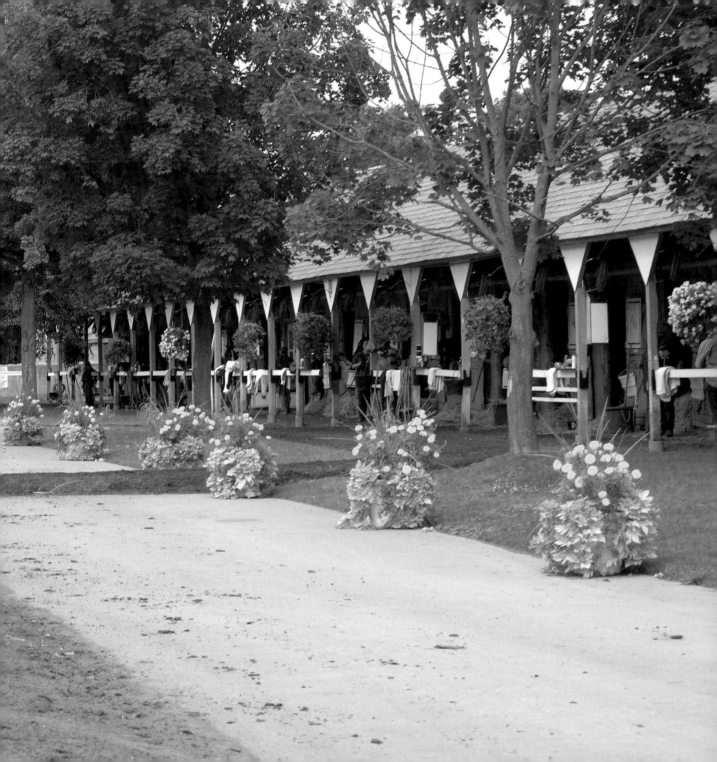

Chapter 3

The Backstretch as Community

James Helmer has described the backstretch as "insulated" from the outside world, with racetrack grooms being "confined" within this other hidden environment (Helmer 1991, 180). He remarks on the sense of friendship, camaraderie, and community this engenders: "There is a sense in which people never really leave the backstretch. Stables, kitchens, and blacksmith shops are much alike; the tracks are similar and the rules about the same. So even on long road trips to different racetracks horse people know how to act. What is more, they can almost always expect to find someone they know from somewhere, and everyone shares such a vast area of common experience that new acquaintances are made easily" (Helmer 1991, 181). In his sociological analysis of the harness track, Helmer has explored the idea that the horse is the focus for activity and contemplation and is the major influence on "systems of meaning." The horse functions "both materially and symbolically" to shape social reality. Making analogies to rodeo workers, circus workers, and farmers, Helmer states that working at the racetrack is much more a "way of life than a way to make a living" (Helmer 1991, 185).

Helmer's assessment of the harness track is congruent with the atmosphere within the thoroughbred "flat track." Consistently, thoroughbred racetrack workers stay within this occupational world as long as possible. Beginning as a hot-walker or groom while in one's teens, one can stay within this occupational milieu for the totality of one's working life. Beyond the work in the

Decorative floral planters demarcate a stable area. A hot-walker walks a racehorse at close of the morning training period.

stable areas of a racetrack, the administration of racing is replete with former racetrackers: judges, stewards, clockers, and office employees can often point to their beginnings in the backstretch.

In the hierarchy of work, the trainer holds the most prestigious occupational position, followed in descending order by exercise rider, groom, and hot-walker. Prestige is further delineated according to work habits. However, Case alerts us to stratification within the backstretch that develops due to trainers' reputations. Trainers, in particular, develop reputations for their horse care, for their mentoring of others, and for their attention to the lives of their stable workers. It is known which trainers assist stable workers with their personal needs such as meals, immigration status, and health care. Longevity of training within the racing environment is highly valued, as is the reputation of mentoring and assisting others. Some trainers, such as Belmont-based Alan Jerkens, who is fondly referred to as the Chief, are specifically known for their sage counsel and encouragement. Case states, "At the racetrack, there are patterns of behaviors named by the community that stratify its members in a more subtle way than simply by occupation" (Case 1984, 271).

To move up the hierarchical ladder, one has to fall in with the right people. For that reason, many people remain at the level of groom or rider, waiting for an opportunity to move into a higher position. Movement between job duties is not always vertical (for example, from groom to assistant trainer to trainer). Those who have served in a long-term capacity in the backstretch may have trained, then exercised horses, and now may be riding while training one's own horse on the side. For those who have served in many capacities, prestige is accorded to those who have made a lifelong commitment to the care of racehorses. Longevity and hard work are admired. For example, outrider Ben Buhacevich began working as a groom in 1969. More than forty years later, he has served as a groom, an exercise rider, a trainer, and now is working as an outrider, serving in a policing and safety role during training and racing. He says: "I started as a groom in '69. Then the fellow I started grooming for wanted me to gallop so I started galloping. Then ponying. I trained. Worked on the gate . . . anything to make it. Anything to make a living."[1]

If one is born into the world of the racetrack, he or she often finds a niche within that world. For example, Antoinette Brocklebank began making racing silks—the colorful jackets worn by jockeys that denote the owner of the horse—after her marriage to a jockey. Their children also found work within the racing world, one as a jockey in Europe, the other as a sales representative for a large horse auction house.[2]

Similarly, those who enter the racetrack world are frequently either exposed to it through family connections or are introduced at a young age. For example, A.J. Credeur began training his father's horses at the age of twelve. Trainers Jerry and Jake Delhomme work together as a training team of father and son. Children are frequently seen within the stable areas of the racetrack, spending time in the morning while their parents are working with the horses, learning racing's concerns at an early age. While in the Saratoga backstretch one morning, I happened upon a lemonade stand, staffed by the young children of an area trainer. Recognizing the presence of young children, and to accommodate the needs of parents, the Belmont Racetrack has an onsite day care situated in the heart of its backstretch.

Some racetrack workers come to the racetrack by way of the horse show circuit, learning and adapting to another way of riding after mastering the art of dressage or other equestrian arts. Some get their start by attending horse races at the myriad of county fairs for which horse and harness racing was previously a regular part of the fair program. Increasingly, although less frequently, some come to it through farming. This was the case for Dave Erb, a retired jockey and horse trainer, who came to horse racing through his experiences on a Nebraska farm. For others, interest in racing may come from a chance encounter with a local racetrack, or an unexpected job opportunity. For many, the exposure comes at an early age with only a later realization that this has become a career path. At eighty-three years old in 2012, Calvin Kaintuck remembers bolting from the dinner table as a young boy in the 1920s and 1930s, to ride the horse-drawn wagons of Baltimore street vendors as they headed back to their stables for the night:

I was in high school and I had a fellow that grew up with me in high school, Raymond Allen. He became a jockey and he was telling us about the racetrack all the time. So we used to go out there then on Saturdays and Sundays and walk horses. We used to get twenty-five cents a head to walk the horses in the morning. But I had already been riding horses around the street, a lot of draft horses. See, when I came along, supermarkets and what you have—didn't have that . . . a lot of the produce was sold by horse and wagon on the street. . . . And I learned to ride those horses because sometimes when they didn't go out the day before they let us ride them . . . wouldn't be too high when they'd go out the next day. Yes, that's how I learned. That was in Baltimore. On the streets, right around the streets we'd ride.

So when I got to the racetrack, I was walking horses in the morning. But one day we took the tack off a horse, another hot-walker and myself, and I put the saddle blanket back up on him and I said, "give me a lift on him." And he was looking all shocked. And I said, "give me a lift up" [laughs]. He gave me a lift and there I was riding the horse around the front of the barn. So all the workers stopped, the grooms, they stopped, and they all were looking. So the trainer came by and I thought he was going to give me heck for getting on his pony like that. And he said, "Calvin, if you want to get on horses, exercise horses, go to my farm and break yearlings this spring and come out with me next spring."

So I thought that was music and I went home and told my parents about it. Well, I couldn't go until school break came. You know, you get out for Christmas time. I went out to the farm and I didn't want to come back. My father came and got me [laughs]. I was fourteen.[3]

Others point to the opening of the Finger Lakes Racecourse in 1962 as being of great importance. Patrick Bovenzi, who now makes his living as a "horse identifier," got his start as a hot-walker, walking horses at the Finger Lakes Racetrack at Canandaigua, as did John Hoffman, stable manager for Palm Meadows Training Facility in Florida. Both spoke of reading the *Racing Form* during high school study hall, and spending summer vacations working at the racetrack as hot-walkers.

For many, finding a job at the racetrack can be the result of being introduced into that environment from someone already on the inside. Just as with Calvin Kaintuck in the 1930s, current stable workers are often introduced through friends or family members. They might be brought to the job through a parent or elder sibling who introduces them to a specific trainer. As Oran Trahan explains: "It's traditional. If you get involved with horses, you start tagging along with your dad at the barn. Next thing you know you're doing it and you become part of it. That's the way it is, you know."[4]

Once employed in one trainer's stables, a stable worker learns which trainers are better employers and who has current openings. Assistant trainer Saul Castellanos explains that he was introduced to the racetrack by his brother over spring break. Arriving from Mexico to the United States for the first time, he was told, "Here is your job, good luck. Now I have to go to Kentucky tomorrow." Castellanos says that he did not know any English and he was living with strangers, but he worked hard as a hot-walker and was able to progress. Today, he considers himself successful with his career at

the racetrack. Another person—groom Juan Salcido Sanchez—was introduced to the job by his father who was already working at the racetrack. Coming from Mexico to take the position, he was mentored by his father. In turn, he has brought two of his eight siblings to work for the same trainer. He has also encouraged his friends to seek work, saying, "It's like a big family."[5] The experience of jockey Gary Stevens concurs. He writes about his elder brother also riding as a jockey and his father beginning the family's involvement as a trainer of quarter horses (Stevens 2002). Others who were interviewed for this book spoke of family members who were trainers, jockey agents, jockeys, or those who held other roles within the corporate world of racing.

Family involvement extends to other track professions. Such is the case with farrier Ray Amato and his family. Amato is regarded one of the best farriers on the Saratoga racetrack. As he is in his eighties and largely retired, he leaves the heavy work of horse-shoeing to his son and nephew. However, Ray still spends each day at the racetrack, working for only a few trainers and providing support to his family members.

A second generation farrier, Ray Amato learned the trade from his father:

I started with my dad. My dad was a horse-shoer. He was in the racetrack in *1940. And prior to that he was shoeing horses in Italy. . . . In 1949, I started with him as an apprentice. It's been a labor of love for me. I'm going to be eighty years old in a couple of days and it's just been great. I just love getting up and coming to work in the morning. I've worked for great people over the years. . . . I'm usually the first horse-shoer on the racetrack. I don't know why but I was always that way. I just love the business. Love the racetrack. Heart to heart I'm a true "racetracker."*

In those years you had to serve a three-year apprenticeship and I started in 1949. Said I was sixteen and I really was fifteen, if I remember right. Then I joined the service when the Korean War broke out. I volunteered and I wound up as a paratrooper with the 82nd Airborne. And when I got through with that tour I started right back with my dad. I had another year and a half to go to complete the three-year. And I completed that and I think that was around 1956, maybe. And . . . I never looked back. I've been busy from the first month I started working. . . . It's just been great.

I'm very fortunate. I'm just shy of eighty years old and I'm still working, which is very odd in this business. My back never bothered me. My dad was that way. My dad had a good back. . . .

After I learned and got on my own and got going and established pretty good in the industry. My dad taught my brother Tony. Then I taught my brother Paddy. Then I taught my son, Ray Jr. And I taught my nephew Chris. And they're all doing good, too. Good horse-shoers . . . Only in the thoroughbred industry and they turned out to be good horse-shoers.[6]

This close-knit world encourages those in it to find a different niche when one role is surrendered, and it is not uncommon to find individuals in every role of racing who can point to an earlier career within the industry. Until his death in 2008, the late Louis Olah was the master of the jockey's silk room for sixty-eight years, whether it was at Saratoga, Belmont, or Aqueduct racetracks in New York. Louis good-naturedly supervised several assistants and the fourteen jockey valets who organized, arranged, laundered, and superintended the wearing of the jockey's silks—the colorful jackets and hats which identify the horses' owners during a race—and who saddle the horses and handle the jockeys' tack. Olah was seventeen years old when he started riding in 1945. As with many young riders, he started out as an apprentice jockey. In 1946 Olah won his first race at the Belmont Racetrack in New York, which moved him into the status of jockey. After a twenty-two-year career, while he was riding for Alan Jerkens in 1967 and contemplating retirement, he was asked if he wanted to try the silk room, filling an existing vacancy. He says, "I never left the jockey's room."

After years of trying, I was finally able to obtain an interview with Louis Olah in 2006. At four feet, eight inches, with a tape measure around his neck, Louis was the unmistakable monarch of the silk room, where he held forth until his death in 2008. I was hard pressed to keep up as he darted from one room to another, pulling silks and equipment to hang on a rack outside the jockey's room. "Did you hear about Louis's other job?" One assistant heckles during my interview, referencing Olah's short stature. "He gets paid on weekends to stand on the front lawn in a jockey's silks." Oh don't listen to him," he whispered to me confidentially. An obviously private man, he was enjoying the attention and the respite from a busy schedule.

On the day of my interview with Olah it is shortly before the first race of that day's meet, but everything is under control. All the silks are ready for the day's meet and are lined up ready to be pulled. There should be no surprises. Owners who are from "out of town," and not registered with the New York Jockey Club must supply their own silks and Louis and his silk room crew must incorporate them into the day's regime. No two silks are alike and Louis had memorized many of the almost four thousand colors and combinations. As we

tour the silk room that day he murmurs that one is out of place and he moves it down the row to a new spot. At the end of the Saratoga Meet, all of these bright jackets will be packed in order in wooden cases to return to Belmont. There will be only a few days' break in order to hang and organize them in anticipation of the downstate racing season.

The frequent movement from backside to other work within the racing hierarchy is evidence of the paternalistic nature of the thoroughbred racing world. While some individuals leave racing behind and go into other professions and careers, those who desire a role can often find a place within many other jobs that support the annual cycle of racing. In the case of Louis Olah, the dangerous role of jockey was replaced with one in which he would continue to interact with jockeys, thus continuing to be part of the community.

While the location of the work may change, the rituals and regimens from one track to another remain roughly the same. In that way, stable workers who move with their horse from one race meet to another will enter each backstretch knowing how to act, and how best to stay safe within a new environment. As pony person Robert Paterno explained in a 2012 interview: "We'll just go somewhere else and do the same thing. But you look at a different tree or a different barn wherever you're going. Different scenery. But the routine stays pretty much the same. You have to have the routine to train all these horses in the amount of time we have. But it's good for the animals. They get used to the routine."[7]

The experienced backstretch worker knows the implicit rules around entering another's stable area, where to stand, how to move around the horses, and the daily training routine. He or she knows that the track opens for training in the early morning hours when it is still dark, that there will be a break in training around 8:00 a.m. when the large tractors make their circuit around the oval to smooth the surface, and that the time for training will end by 10:30 a.m. He or she will know that any business to be conducted needs to occur within that time period, and trainers will most likely be found congregated along the fence to watch their horses go through their daily routines. The morning workouts conclude by 11:00 a.m., and a 1:00 p.m. post time for the first race of the afternoon allows stable workers and trainers a quick meal and a shower before heading to the racetrack for an afternoon at the races. By 1:00 p.m. the stables will be quiet with horses dozing sleepily in stalls and only a watchman in each trainer's stables to keep an eye on the horses. Even if not planning to attend the afternoon races, most stable workers have returned home to shower, eat, sleep, and relax before returning back in the late afternoon to do another feeding.

If one is living within the backstretch in one of the many dormitories or housing units, one's work site becomes a place of leisure in the evening hours. Forbidden from cooking in track housing because of the fear of fires, backstretch workers can be seen cooking outside on portable barbeques. Bicycles are the dominant mode of transportation from place to place and backstretch organizations organize after-hours bingo nights, soccer and basketball leagues, religious services, and English-language classes.

The backstretch is a "place made culturally meaningful" by the intensity of the work experience and by the circumscribed nature of the community of workers. One finds an entire community tucked away on the edges of a racetrack, including housing, stables, businesses, offices, and purveyors of food. Besides horses, one sees a menagerie of other farm animals: dogs, chickens, and goats predominate. Vehicles abound, including bicycles, golf carts, trucks, and cars. One's olfactory senses are assaulted by the smells of hay and manure. The sounds of the stables are varied. In moving through the stable areas, one hears snatches of song (either sung or from a radio), the sounds of chickens, whistling, and the distinctive sound of hooves on pavement. A groom hails another in greeting, asking, "Is this where you are 'barning'?"[8] Overall, however, it is a quiet environment as workers know that sudden loud noises can startle a horse, creating a dangerous environment within the stable areas.

In describing the backstretch, Case states, "Though the nature of track life frustrates affective relationships with those on the "outside," workers maintain them inside the fence." This observation is supported by pony person Robert Paterno:

That's what stops a lot of people. That's what makes people leave the racetrack. They'll get married, they'll have kids and they want to stay in one place. They might still stay around horses but they might go to one racetrack and just stay there, maybe it only races part of the year. Whereas a certain percentage of people stay on the racetrack all the time and we move all the time but that's another lifestyle and you get used to it. It has its good point and bad points. A lot of people say when they get older they get tired of being on the road. I guess I haven't gotten tired of that. I'm a little tired of it. [pause] I still do it, so . . .[9]

Relationships within the backstretch are characterized by intimacy, the sharing of belongings, and an emotional investment in one another despite distance and time (Case 1991, 89). Sarah Arnold began working at the racetrack as a groom. While in that position she

trained to become an exercise rider, riding more and more difficult horses as her skills progressed. When she and I were first introduced, she was working in the stables of her husband, who had originally employed her as an exercise rider. She characterized the racetrack in this way:

> *The racetrack is such a strange lifestyle. A lot of moving around. Weird hours. So you do see a lot of . . . couples on the racetrack that work on the racetrack. A lot of husband and wife teams. There are many of those. You see exercise riders that are married to each other . . . because of the lifestyle and I think it's very hard. Especially if you have children. If you do have children, it's hard because you're going to be split up if you don't understand the lifestyle once you have kids. Yeah, I think there are a lot of couples who work together on the racetrack. I'd say most people on the racetrack—their spouses, or girlfriends, or boyfriends, they also work on the racetrack. I'd say 75 percent, I'd say.[10]*

Yoram Carmeli has written of fieldwork conducted within a British circus in 1975 and 1979. The picture of life behind the scenes is strongly reminiscent of the backstretch environment. Carmeli writes: "Theirs is not an isolation of living apart. . . . It is rather an experience of existential isolation, isolation from life itself. . . . Within the timeless space that they constitute, the travelers' own experience of time and self is anchored in the closed realms of the relations between generations and family genealogies and in the fabrics of their family acts" (Carmeli 1991).

Racetrackers point to the difficulties of maintaining family life and relationships because of the long hours and the constant travelling. One retired trainer stated:

> *It takes away from your family. I got back home one evening . . . It was about 1:30 in the morning. And my son was probably, he was about nine years old. And my wife left a note on the table and that's when I realized I got to hire one more guy to make sure that my work is getting done in the barn. Because the letter stated very clearly. She said, "Your son is nine years old. You leave here in the morning at 5:00 o'clock. He's sleeping. You come back at noon to eat lunch, take a nap and you leave and you're hauling back to the racetrack again. You're going to run. You get back home at 1:00 in the morning. He's sleeping. He's nine years old and you haven't seen him grow up."*
>
> *And that really hit home. It tore me up. I sat at the table and cried that night and said I have to do something about this.[11]*

Several trainers with whom I spoke talked about their conscious efforts to keep their children away from this environment so that their children could develop other interests. In a few cases, those children have excelled in their chosen professions and then have dabbled in that world themselves as owners of racehorses. Jake Delhomme was able to excel in football, turning professional after college. Now, he is the owner of several racehorses that his father, Jerry Delhomme, trains. Similarly, Kaintuck remarks that his son is an investment broker looking to invest in a horse.[12]

In such a circumscribed environment, friendships are important to maintain a support network. Relationships last for many years. Bob Paterno said this about relationships within the backstretch: "No matter where I go, if I go to a racetrack I've never been at before, I know that sooner or later I'll run into somebody that I know. And sometimes I meet people that I haven't seen in twenty years. And it's just like we hadn't seen each other since yesterday."[13] Says trainer Oran Trahan, "It's a hard life but it's a fascinating business. It's a challenging business. If that's the right word. If you're in the racing business after a while the backside becomes your family. It becomes your friend. That's the way it is. The people we associate with are probably connected with the horse racing. It's unique."[14]

The backstretch is where the stables are located, but also exists as an idea in the imagination. It is referenced when speaking of any cluster of stables for the thoroughbred industry, whether at a training track or part of a public setting. "Backstretch" refers to the site of work just as "backstretch workers" are those who toil within the stable areas. This landscape of possibility for those who anticipate future success in racing or in the attainment of skills and prestige can also be one of despair for those who have given up thoughts of accomplishment, succumbed to the numbness of the daily routine, or lost their way through drugs, alcohol, or gambling—the three distractions prevalent within the backstretch community.

The backstretch has an aesthetic of orderliness. Stables are laid out in parallel lines, and each stable exists as a well-contained and controlled area. Each day has a routine and each task has its technique. There is a proper way to curry a horse, to wrap its legs, to walk. Walking is always done clockwise in the shedrow, at a slow and methodical pace, and at a certain distance from its walker. The ground around the stables is raked into smooth concentric circles at the conclusion of each day's grooming. An uneven ground could cause a horse to stumble, or to kick up an unexpected stone. The desire is for neatness, regularity, and a certain rhythm.

Trainers proclaim their territories through the use of furniture, plantings, and color. While barns are not allowed to be painted to individual tastes, as racetracks have their own maintenance and management departments who manage the property and decide the appearance of the physical plant, flowers and wall decorations indicate a trainer's own trademark colors. Colors and symbols can indicate ethnicity, religious belief, and family identity. For example, Irish trainers decorate their stables in the orange and green of the Irish flag or include Celtic symbolism on their stable decorations. Trainer H. James Bond uses 007 in his designs, making reference to the literary figure made famous by Ian Fleming and his novels about James Bond, a spy with the code name of 007. With the goal of assisting general knowledge about horse racing, the Saratoga-based fan group ThoroFan issues a "Guide to Saratoga Race Course Trainers' Saddle Towels," which serves as a reference for public spectators of the early-morning training period.[15] Where trainers once were identified with a specific stable and owner, today's trainer may train several horses at the same time, all with different owners. Replacing the symbols of stable ownership, the use of color and symbol now indicates the trainer in charge.

Trainers also use the positioning of lawn furniture and small outbuildings, such as pagodas, to demarcate their territories within the backstretch. As an extension of the barn and its shedrow, the use of portable, weather-resistant furniture gives the ambiance of a backyard setting. Trainers and their families use this location to eat; to meet with sponsoring owners, jockeys, and other contract personnel; and to socialize with fellow trainers. In this way, the stable becomes an extension of one's home.

The use of symbol and color is a strategy also employed by the exercise rider. Flags, indicating one's nationality, are worn on protective vests and helmets, or an openly gay rider can sport the identifying rainbow colored triangle. While serving as a pony person for the afternoon races, Lorna Chavez dresses in a pink vest and riding helmet and wears an identifiable "playboy bunny" affixed to her riding helmet. When asked about the symbolism, she explains that she started wearing the playboy bunny as a "dare" and now it is part of her regular appearance. Yvonne Lockwood writes of a similar impulse for decoration in industrial settings, as steelworkers and autoworkers decorate their hardhats or other items of work apparel as an attempt to personalize and individualize the work environment (Lockwood 1984). Horses used as "ponies" within the backstretch can also reflect the creative impulses of their attentive owners. Juan Galbez, a pony person originally from Chile, can be seen in the pre-race post parade riding a horse resplendent with braided mane and tail.

Chapter 4

The Horse Race as Performance

On this morning, I enter the turnstile of the Saratoga Racetrack before the start of the day's races. I find myself in the border area between the entrance on Union Avenue and the grandstand. At this early pre-race hour, a lone custodian is sweeping up the last remains of yesterday's debris, and food vendors are beginning to start their day's operations.

Upon entering through the turnstile I enter a grassy area, canopied by hardwoods. This "back of the grandstand" creates a buffer between the "outside" world, which is the residential neighborhood of Union Avenue, and the "inside," which is the Saratoga Flat Track. This "backyard" of the Saratoga Racetrack is not focused specifically on racing: there are picnic tables, playground equipment, and vendors of food and memorabilia, the presence of large-screen video monitors being the only indication of the business of racing that will begin in a few hours. The focus here on the social aspects of racing appeals to the casual observer. Cohorts of office workers, families, and college friends find their way to this area, which is separated from the horsemen and gamblers who observe the day's races within the confines of the grandstand. In keeping with the carnival atmosphere to erupt in just a few hours, spectators will be treated to music and a variety of food offerings. Young parents keep an eye on their children on the playground, and well-laden picnic tables offer enough food for an afternoon of eating and drinking. Spectators drift toward the monitors for the start of each race; after its few

Trainer and jockey having conversation before a race, Tampa By Downs, Florida, February 2013.

34

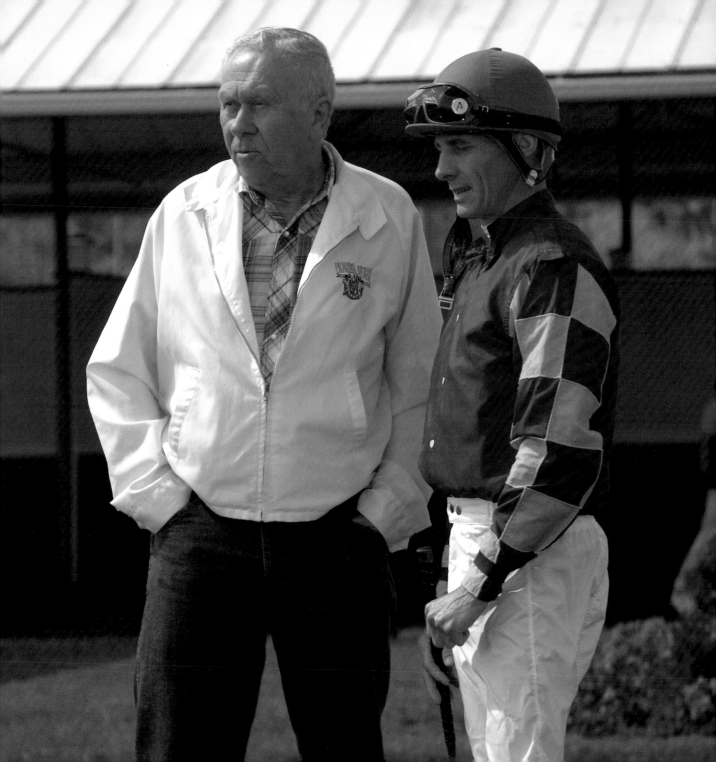

minutes of racing, they go back to their picnic areas to wait for the next "call to the post."

On this morning, early arrivals mix with vendors who are setting up their wares. Food, artwork, or racing programs typically are sold in the picnic area in this backyard setting. The early-morning workouts of the horses have largely concluded for the day, with only a few horses continuing to "breeze" before the track closes for conditioning at 10:00 a.m. At Saratoga a popular activity is to come early to watch the training period until mid-morning and then to remain for the racing in the early afternoon. Those coming early to the racetrack are laden with coolers and picnic baskets and find the perfect location for a full day of racing and socializing with friends and family.

One of the appeals for the spectators at the Saratoga Race Course is the horse trail that runs right through the picnic area outside of the grandstand. Horses coming from the stable areas travel a private corridor—the horse path—until they pass through the chain-link fence that separates the track area (which is off limits to the public) from the back of the grandstand area. In the backyard of the grandstand, there is only a strand of chain which barely separates the horse path from the rest of the public area, offering an illusion of safety while granting an opportunity to experience the entrance of each day's athletes at close proximity. Spectators line this ersatz fence to examine

the horses on their way to the paddock, where they will be saddled and mounted by their respective riders. This is the first glimpse visitors will see of each entry in the next race and the preamble to the post time parade, which leads into the loading of the starting gate and the cry "They're off!"

In Saratoga, while the horse is escorted to the starting gate by a pony person,[1] it is the groom who most often escorts the horse through the crowd and into the paddock area. In commenting upon this public role to me, a groom offered a glimpse into the anonymity of stable work. He reflected that while the groom is moving the horses through the crowd, everyone is looking at the horse, unaware of the person who is actually leading the horse to the paddock:[2]

I don't feel bad about it. I am happy to be here. I am happy to do this job I really like. I feel happy with the horses all the time. That is why I do this job. I really like it.... Every time when you see the Racing Form or anything, about news of the horses, they always talk about the horse, about the trainer, the scores, about the owner, but they never mention, "Oh, this is the groom that take [sic] care of this horse." When the horse wins the big race—like the Kentucky Derby—they never talk about the groom or about the hot walker. Sometimes about

the riders. But they never talk about us, you know. It's just the trainer, the owner, the jockey, and that's all.

But, it's just like I'm saying. To get to that point we go through a lot. We do many things. And it's a lot of people: the hot-walkers, the foreman, the groom, and the vet, and the blacksmith. It's a lot of people behind the race. It's not just "win a race" and that's all. No. They never mention nothing [sic] about us, you know. And sometimes we can feel bad about it because in the end it's my job. It's my job. Sometimes I don't get any credit but it's my job. And the horse gets there because I did a good job. Because I keep him safe, I keep the horse ready to get there. And we don't get any credit about it. We feel bad but we understand. On the end I'm just a groom. . . .

I think we are important. You know. I think that to win a big race is because everybody is doing a big job. . . . Usually I don't mention that . . . but it's true. It's true. It is.[3]

Rosecrance (1985), in his study of the backstretches of racetracks in Los Angeles and New Orleans, Louisiana has suggested that grooms are "socially invisible" due to the "backstage[4] nature of their milieu, the 'dirty work' nature of their tasks, and the self-contained nature of

their environment" (Helmer 1991). Indeed, the person leading the horse is seldom acknowledged during a race meet as all eyes are on the animal on the other end of the lead. As was articulated by another groom at Saratoga:

The jockeys get 10 percent [of the purse]. It's too much for them. I've spent more time with this horse in the morning time than with my wife. You know what I'm saying? I'm feeling like the groom should be getting more than what they're getting. How much time do they spend with them? Two minutes? They're on them maybe two minutes. They come out and work them sometime and that's it. You could put a monkey on a horse and it could win. They should at least recognize the groom and the hot walker.[5]

This connection between groom and horse is important and the pride of caretaking is evident.

This guy, his name is James. He's been rubbing this gray colt. For the longest time. For the whole month. And now he's getting good. . . . All the good [horses] are in the other barn. So "nice going." "Good." He's really doing good. They took [the horse] away and put him in the better barn! I would have quit! . . . Leave him with that

guy he's doing good with him. So I think that's pretty bad.[6]

The groom delivers the horse to the paddock area and stays until the horse is mounted and ridden onto the track. Just as an actor undergoes a transition from private citizen to his or her role on stage, the horse undergoes a comparable transition through the elaborate ceremony that is the preamble for the race. The actual race, which is only minutes in duration, is the very short culmination of months of training and anticipation. In moving from stable to racetrack, the horse makes his final transformation from horse to (potential) star.

Upon its entry into the paddock, the horse identifier first checks the horse's markings and lip tattoo against the day's entry forms. The horse is then led to the stall that corresponds to his position in the race and is tacked up with saddle and bridle by a valet, working in concert with the trainer. Often joining them in the paddock area is the owner, who plays a largely ceremonial function in this paddock ritual.[7] Once tacked up, the horse is led around the paddock area in a clockwise fashion by the groom. This provides an opportunity for bettors (who line the fence around the paddock) to survey the horse, read his race statistics in the day's program, and compare him to the rest of the field. While the spectators make their assessments, those within the interior of

the paddock appear unaware of those outside of this ritual space. The jockey, escorted by his valet, has meanwhile entered the arena. He is met by the trainer, who introduces him to the owner. This triumvirate briefly shares the spotlight with their horse. It is these three who will benefit most from a win at the upcoming race and who will meet again in the winner's circle if their horse makes it to the finish line at the front of the pack.

After a brief period of time that appears to be largely devoid of activity, the call of "riders up," comes from the paddock judge. At this point there is a flurry of activity. The jockey is assisted to his seat on the horse, either by his valet or the trainer. The owner beats a swift retreat under the paddock rail to take his seat in the grandstand. The groom then leads the horse and rider out of the paddock and down the pathway to the racetrack. He will be met there by the pony person, who will attach his own lead to the horse to be led in the post parade to the starting gate.[8] This is the first time the horses and riders are visible to the rest of the grandstand. They make a brief appearance in front of the grandstand and are then led around the racetrack to the backstretch side, where they will be handed off again to the starting gate attendants to be loaded into the gates for the race.

After the race's conclusion, each horse is allowed to cool off by slowly decreasing speed

and then by being led around the track by the pony person who is contracted to that horse. The horses and their riders make one complete lap around the track, being led by their pony person. The jockey is then assisted off the horse by the valet, and the saddle and bridle are removed. Former jockey Bill Boland spoke of the post-race rituals:

> Well I'll tell you exactly what a jock does. He's weighed out with his tack like he's going to ride. He goes to his paddock, gets his orders. He goes out to ride. He comes back, which is a tradition but they don't really enforce it anymore. He's supposed to salute the judges to get permission to get off his horse. But that kind of went by the wayside But before if you didn't you'd get fined for it. They used to post a guy down by the finish and also there would be a steward looking over and you had to salute him and he would, like this with his program, give you permission to get off your horse.[9]

The horse is delivered back to the groom, who will escort him to the barn. The groom is sometimes accompanied by the hot-walker, who will help carry the tack and clean up the racetrack from any fecal material that is deposited by the horse. A successful horse's owner, trainer, and jockey meet briefly in the winner's circle for an official picture and congratulations. In a reversal of the paddock ritual, which takes place behind the grandstand, the winner's circle is located on the "frontside" of the grandstand. In this prominent spot the owner, trainer, and jockey pose with the winning horse for a brief photograph documenting their just-completed win. Louisiana-based trainer Oran Trahan refers to this historic moment as "taking a picture": "It can be enjoyable for the sake of winning a race. Or 'taking a picture,' we say. That's the most joyful time you'll have—at that time. Taking a picture. And it doesn't matter if it's a $5,000 claimer or a handicapped race. You get a lot of joy there. All your work, your planning, sort of comes together. But you work for it . . ."

After the photograph is taken, cementing the event in the trainer's and owner's memory, the horse is led away by the groom to return to the stable area where it will be walked by its hot-walker and possibly bathed, with ice applied to its legs to alleviate muscle pain and soreness.

A full day of racing typically includes nine to ten races, with about a half hour lull between each race. At the Saratoga Racetrack, the first race of the day begins at 1:00 p.m. and a day of racing can conclude about 6:00 p.m. A day's racing program includes a variety of programmatic elements grouping entries by horses' age, place of birth, whether or not a horse

has ever won a race, or the sex of the horse. An *allowance race* sets other race conditions such the number of wins a horse as achieved, with the racing secretary specifying a base weight that the horse will carry and assigning additional weight based upon past performance or the amount of money a horse has won. Similarly, a *handicap race* has the assignation of weight based on an evaluation of the horse's potential. The highest level, a *stakes race*, carries the largest prize or purse and attracts the most competitive field of horses. On the lowest end, a *claiming race* provides an opportunity for someone to purchase the winning horse, which allows an owner to remove an underperforming horse from his stable while at the same time providing an opportunity for another trainer to purchase a horse at a reduced price. The hope is that, given a new environment and different training methods, the horse will succeed where he did not previously. The lure of success has been fueled by the legendary wins of such "claimers" as Seabiscuit, whose ownership was transferred as the result of a $7,000 claiming race (Hillenbrand 2001).

The variety of mechanisms for grouping horses provides a wealth of opportunities for spectators to determine their bets for each race. Handicappers, who look at the race line-up and try to determine the outcome before the race, look at the distance of the race, the weight the horse carries, the track conditions,

the skill of the rider, the horse's past performance, the horse's breeding, and any of the horse's idiosyncrasies before making their predictions (Alfange n.d.). In that lull between races during an afternoon's competition, spectators variously study their racing program to place their next bets, converse with their companions, or wander the backyard area to listen to musical entertainment, sample the food offered by food vendors, or view the horses in the paddock area.

With its rituals, pageantry, and defined roles, the thoroughbred racetrack constitutes the location for a cultural performance that dates from the eighteenth century in this country, with its origins in Europe and the Middle East. Within the thoroughbred race meet, highly trained athletes (both horses and jockeys) take part in a preliminary set of ritual activities leading up to the moment of extreme contest that pits horse against horse in an atmosphere of risk.

In her studies of the American rodeo, Beverly Stoeltje describes the "discourse of display and exhibition" that is part of the "ritual" that is the rodeo (Stoeltje 1993). Similarly, the thoroughbred race environment comprises a unique blend of contest and performance. This idea of performance is not unique to the Saratoga racetrack; Derby Day at Churchill Downs in Kentucky has also been well documented as cultural performance.[10] Within the

environment of the race-meet, the aggregation of horse parades, ritual, color, drama, and game or contest provide an experience that is appealing on many levels. Thoroughbred horse races at Saratoga include many of the same elements of other high-level sporting events: "visually rich, multi-focused events, possessing well-defined roles of performers and spectators" (MacAloon 1984). As studied by MacAloon, key elements include a parade of athletes, a field awash with color, an escalation of tension to the actual start of the contest, and a coalescing of sentiment creating a feeling of "communitas"[11] among the spectators as they root for and cheer on their athletes—the culmination of which is the outcome of the race. In keeping with MacAloon's intensification of experience, spectators at Saratoga experience a lush environment, filled with color and ritual. As with many cultural performances and dramas,[12] the race meet takes the form of the "what if." It is a moment of speculation and of possibility. "What if" defines the mindset of all those who have worked with a specific horse to prepare it for the race, and is the state of mind of the spectator viewing the contest. This "what if" is also the motivation for the gambling that forms a large part of horse racing and its appeal.

The horse is the main actor in this drama that is acted out multiple times in one day of racing. Repetition is the norm; each race adheres to a formula that provides continuity over time and space. While the pre-race ritual may differ slightly according to the layout or architecture of the racetrack, it remains largely intact, differing little in substance from one location to another. As with many other aspects of thoroughbred horse racing, repetition mitigates risk. A horse that enters a race at Saratoga will not find an unfamiliar preamble from that experienced at any other racetrack.

This sport that was a result of the connections between livestock, farming, and leisure was codified in the twentieth and twenty-first centuries to result in a multi-million-dollar industry. While the dichotomies between owner, trainer, and rider are sharply defined within the rarefied atmosphere of the most prestigious racetracks such as Saratoga and Churchill Downs, the rural origins of the sport remain, especially at smaller and less competitive arenas. At racetracks throughout the United States, small training operations (some with owner-trainer stables) continue to attract a dedicated clientele of enthusiasts.

In the public arena of the thoroughbred racetrack, leisure is one motivator for those attending the race. Leisure is defined as "a state of being idle." Its pleasure lies in its escape from "determined passages of time" and a "release from restraint" (Sutton-Smith and Kelly-Byrne 1984, 77). At its origins, horse racing was a means through which rural populations

could enjoy a weekend activity. Although largely organized by men, a weekly race meet was considered an event to attract the entire family. Within rural pockets, such as found within Cajun communities of rural southern Louisiana, horse racing was and continues to play an important role in the community, with spectators drawn from all economic groups within the community.

By the beginning of the twentieth century, urban racetracks in New York State began to actively campaign to attract both women and working-class people to the races. Heretofore, horse racing at one of the many urban racetracks in New York had been an activity constructed solely for wealthy men. After the Civil War, new tracks being built within the metropolitan New York area constructed special viewing stands for women and provided opportunities for members of the working classes to view races. Of particular note was Jerome Park, located in what is now the East Bronx. Built by Rochester native and racing enthusiast Leonard Jerome in 1866, the racetrack was built to accommodate female spectators. Working-class audiences could view the proceedings from an adjacent hilltop and the track's easy accessibility to transportation made it a destination for picnickers (Riess 2011, 31).

Today Saratoga, in particular, is renowned for its park-like setting. The grandstand at the Saratoga Race Track was built in 1864 and is one of the oldest grandstands in the United States. This historic structure is open on the back, inviting people into its cool, ceilinged interior. The spectators in the grandstand area, both inside the historic structure and outside in the backyard area, are treated to an atmosphere that bespeaks of picnics and excursions in the country. Its bucolic setting has been described in stark contrast to the concrete-and-glass structures that constitute both Belmont and Aqueduct Racetracks in metropolitan New York (*The Track at Saratoga* 2013). While the horse is the main protagonist in the drama that unfolds on the frontside of the racetrack, the horse is also the main actor in the working life of the backstretch. The performance that is the care of the racehorse is the flip side of what occurs within the race arena.

On the opposite end of the spectrum from leisure is that which occurs in the backside of the racetrack. The horse is the center of this world of work. The horse is aristocrat and worker, master and slave. It dictates the work of others and it is upon its body that the work is enacted. Just as the human body can be shaped, inscribed, and constructed,[13] the equine body is constructed to make an elite athlete. Through work, the horse's body is shaped and molded by the stable workers to render it most effective, with its athleticism being of primary importance. The daily workouts

are imposed upon it to provide opportunity for the horse to reach its full potential. Just as with the training regimen of human athletes, the habitual nature of training practice shapes and molds the body. The routine is unending, providing few opportunities for the horse's rest and relaxation until it ceases to perform well at the racetrack. In the best of cases, the horse is retired from racing and can end its days working as a "pony" or at pasture. If it has performed well, it can serve as a breeding horse, retiring to a breeding facility. At the worst, it is disposed of, or it is raced until it suffers an injury, breakdown, or death.

The training track at Palm Meadow Training Facility, Florida, February 2013.

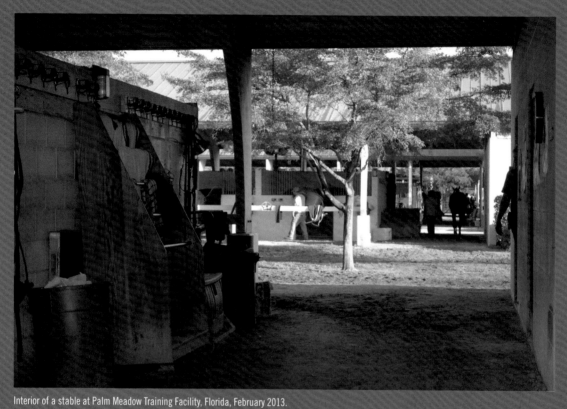

Interior of a stable at Palm Meadow Training Facility, Florida, February 2013.

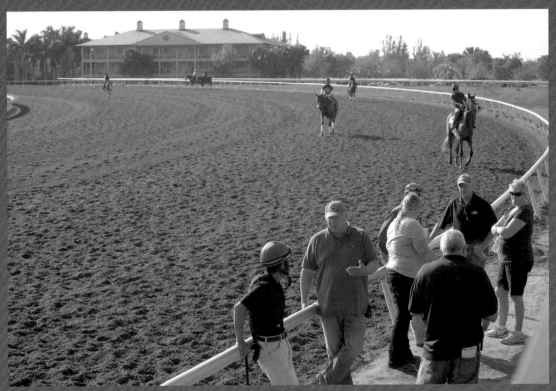

Trainers "at the rail" during morning workouts at Palm Meadow Training Facility, Florida, February 2013. The time spent at the rail by trainers is used to observe their respective horses as they train. This morning routine also allows informal conversation between trainers. Because trainers typically spend time observing their horses during morning training sessions, others wishing to speak to trainers often seek them out at this time. For example, a jockey wishing to ride in an upcoming race might be introduced to the trainer during the morning workouts, or a jockey's agent might know to advocate for his client "at the rail."

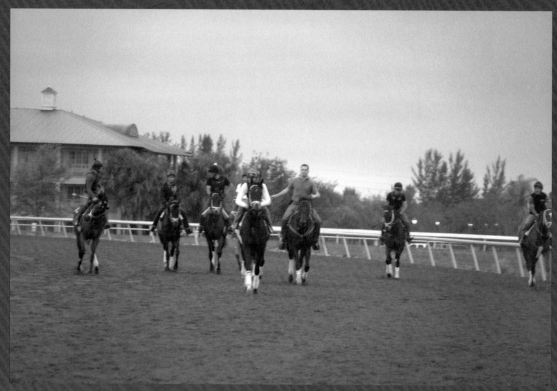

Riders on training track at Palm Meadows Training Facility, Florida, February 2013. From the "colors" worn by the riders, at least three different trainers' horses are represented. The helmet-less rider in the center is "ponying" another horse, leading a horse by a rein while seated on a "pony." This is done to assist less experienced horses with acclimating to the atmosphere of training or racing surrounded by other horses. A pony is a working horse, often a retired racehorse, that is able to assist with training or with management of racehorses before and after a race.

Portrait of Ray Amato, farrier, February 2013.

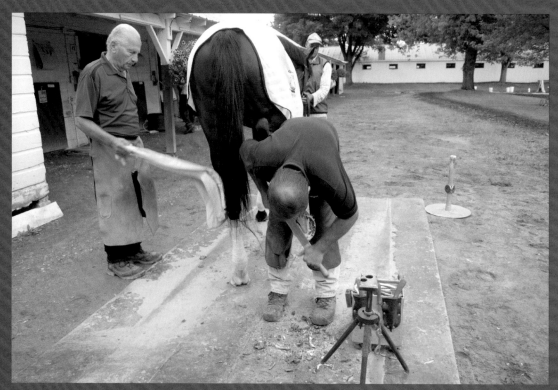

Ray Amato assisting his son, Ray Jr., at Saratoga Racetrack, Saratoga Springs, NY, August 2014. Ray Amato Sr. joked to me that he had returned to the role of apprentice, shooing away flies so that the horse would remain comfortable and therefore "quiet" while being shod. The son of a farrier, Ray Sr. taught his skills to both his own son and a nephew. Today, he and his son work in tandem at thoroughbred racetracks.

Horses "breezing" during morning training at Palm Meadows Training Facility, Florida, February 2013. To breeze a horse is to allow it to gallop at a high rate of speed, replicating a race situation.

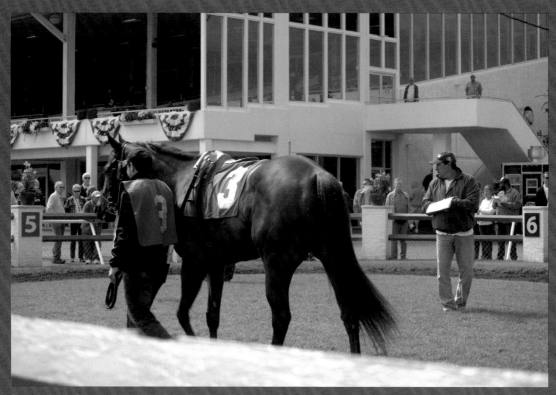

Pre-race parade of horses in the paddock, Tampa Bay Downs, February 2013. This before-race ritual allows the public to view horses before the race.

The "hand-off" of a race from the groom to a pony who will escort the horse to the starting gate in the post parade. The pony person is dressed in green and is contracted by the trainer to serve as the racehorse's escort. The job of the pony person is to assist the jockey before the start of the race to mitigate any risk. This photograph was taken at Tampa Bay Downs, Florida, February 2013.

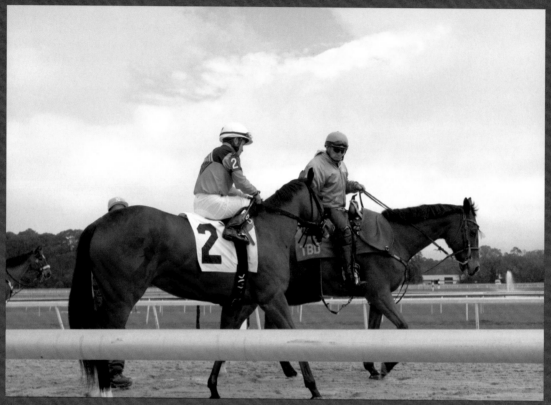

A pony person escorting a horse and jockey to the starting gate, Tampa Bay Downs, Florida, February 2013.

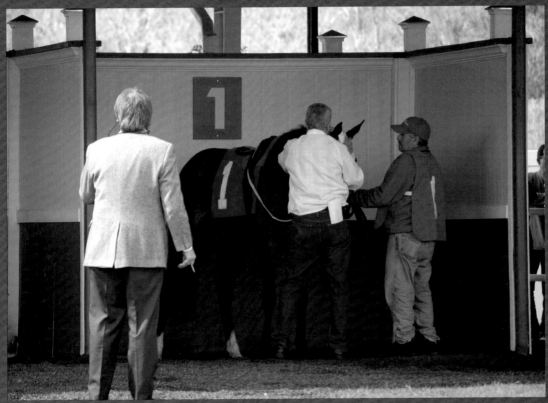

A trainer and groom saddling a horse before the race, Tampa Bay Downs, Florida, February 2013. Striding into the stable is Patrick Bovenzi, the horse identifier, who will certify through identifying the horses' tattoos and markings that each horse in the race is the legitimate entrant.

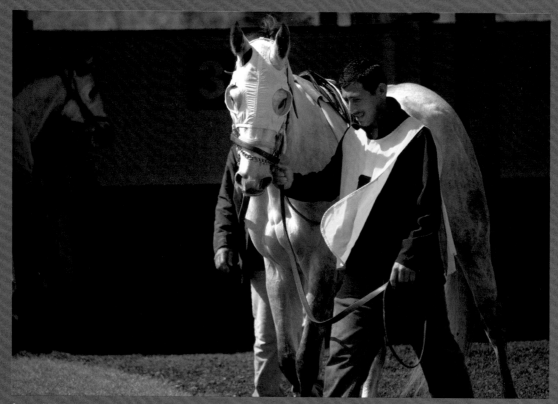

Groom with horse in the paddock parade, Tampa Bay Downs, Florida, February 2013.

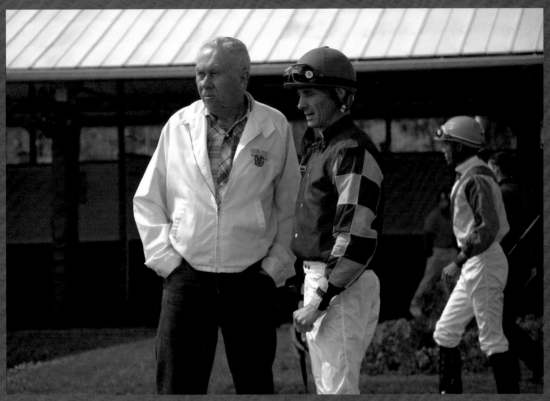

Trainer and jockey having conversation before a race, Tampa By Downs, Florida, February 2013.

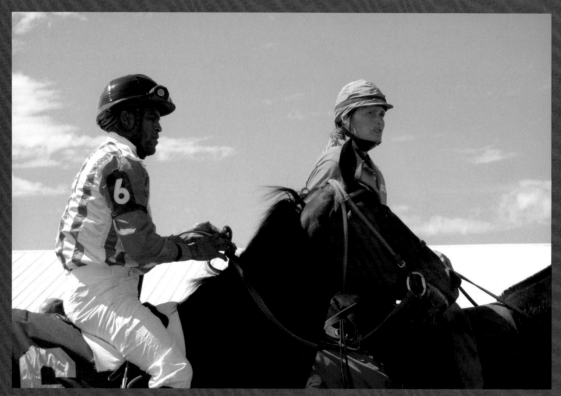

Pony person and jockey on the way to starting gate, Tampa Bay Downs, Florida, February 2013.

After the race. The groom, valet, and trainer all assist with removing silks and saddle after the end of the race, Tampa Bay Downs, Florida, February 2013.

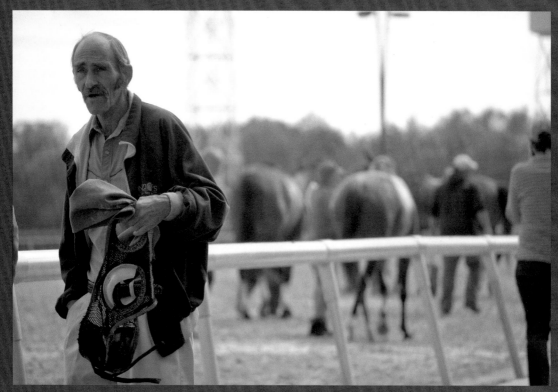

Unidentified groom, Tampa Bay Downs, Florida, February 2013.

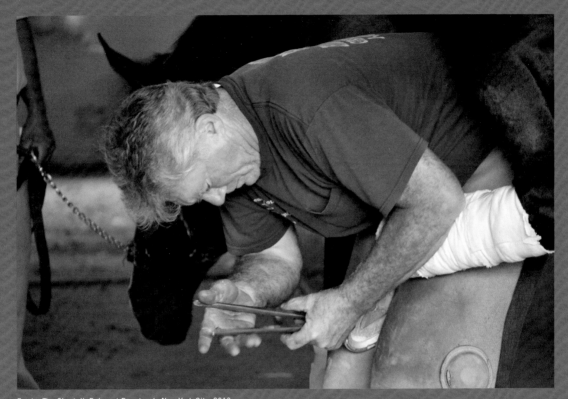

Farrier Tim Shortell, Belmont Racetrack, New York City, 2013.

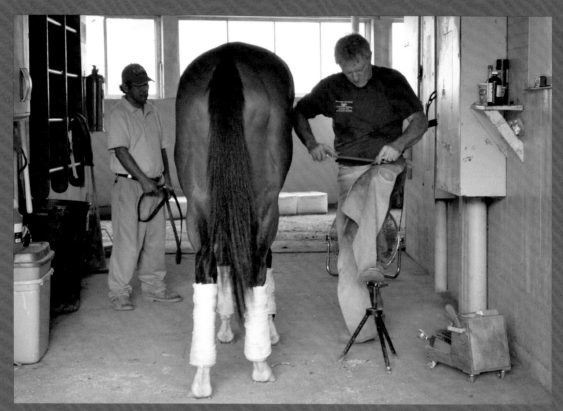

Farrier Tim Shortell of Glen Cove, New York, shoeing a horse at Belmont Racetrack, New York City, 2012. Shortell began working in the stable environment when he was twelve years old, helping his uncle care for racehorses. While helping in the barns, he observed farriers at work and decided that horse shoeing was his career choice. Shortell entered an apprenticeship situation, and after an apprenticeship period of four years began shoeing horses. At the beginning, his work was mostly with horses in the horse show circuit. Shortell began shoeing at the racetrack in 1985. He says that most shoeing work comes through word of mouth: "When you work for a trainer that is established and successful, it works well for you, because it gets you attention and you just build from there."

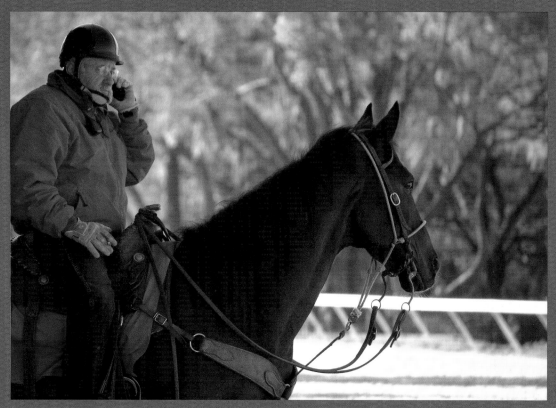

Outrider Ben Buhacevich, at Tampa Bay Downs, Florida, February 2013. During the morning training period, an outrider stands ready to assist any rider who is experiencing difficulty. The outrider also makes sure that riders are wearing the proper safety gear (a riding helmet and a vest).

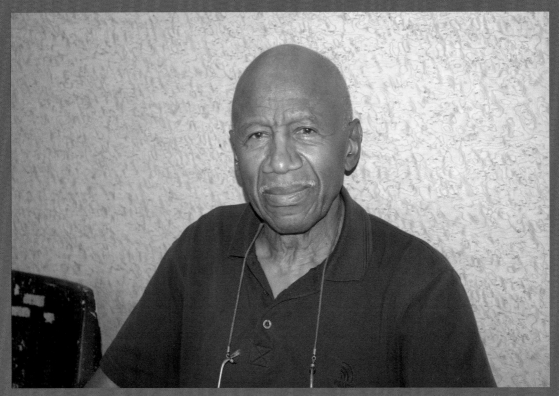

Exercise rider Calvin Kaintuck, Belmont Racetrack, New York City, 2012. Born in 1929, Kaintuck recalls riding the delivery horses owned by street vendors that delivered produce, baked goods, and dairy on Baltimore's city streets. He says, "I learned to ride those horses because sometimes when they didn't go out the day before they let us ride them so they wouldn't be too high when they'd go out the next day. Yes, that's how I learned." While maintaining morning jobs as an exercise rider he attended Community College of Baltimore, and through their co-op program started his career as an aircraft electrician for Westinghouse Corporation and Randall Lockheed (now Lockheed Martin). He would often ride horses in the morning while juggling shifts at Westinghouse.

Trainer Cleveland "V" Johnson. Originally from Rayne, Louisiana, One of only a few African American trainers working within racing, Johnson got his start as a young boy riding match races in rural Louisiana. After high school, he made his way to Boston and landed work with trainer, Butch Lenzini, eventually moving from groom to assistant trainer. Today Johnson stables his horses at Aqueduct Racetrack and races predominantly at Belmont and Aqueduct.

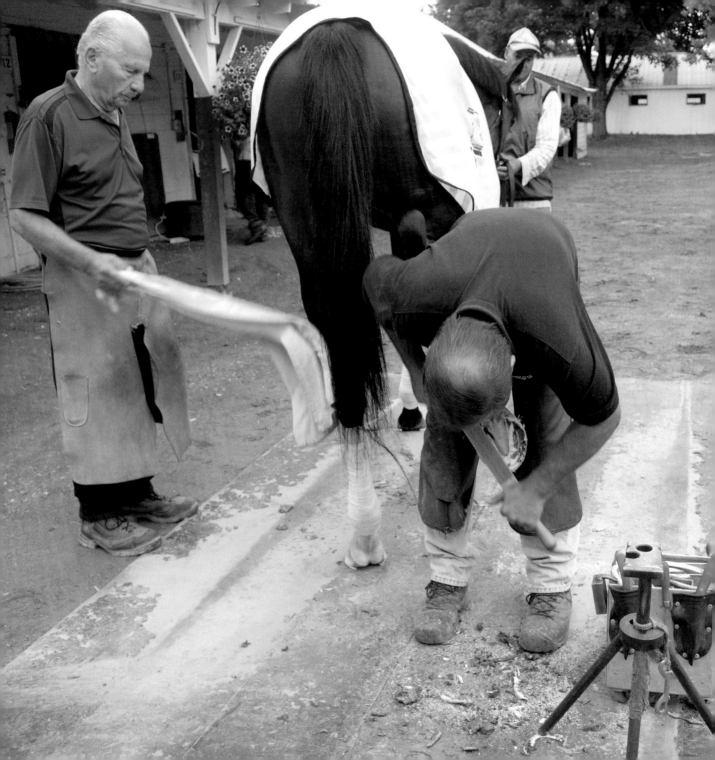

Chapter 5

The Good Horseman

Getting and Keeping a Horse

In the early morning hours, I stop a rider to ask if he would consent to an interview. As I round the wall of a barn later that afternoon, he is waiting for me. Before agreeing to sit down with me, however, I reassure him that my goals are to document the folklife and cultural milieu of the racetrack, not instances of questionable training practices. I reside in close proximity to Saratoga Springs and its racetrack, and annually read the descriptions of animal mistreatment that accompanies every racing season at Saratoga. Most recently, after a number of highly publicized horse deaths in the New York racing industry in 2012–13, there has been renewed scrutiny, both within the New York Racing Association and regulatory bodies for the State of New York.[1]

In 2008 the American Association of Equine Practitioners, a worldwide professional organization for equine veterinarians, released a white paper on the care and safety of thoroughbred racehorses, in which they point to the formidable challenges of catastrophic injuries, medication usage, and a changing societal view of the appropriate use of horses in competition. The report makes recommendations in the following key areas of the thoroughbred horse industry: societal change and the public perception of horse racing, the racing business model, the veterinarian-owner-trainer relationship, and medication (AAEP Racing Task Force 2008).

Ray Amato assisting his son, Ray Jr., at Saratoga Racetrack, Saratoga Springs, NY, August 2014. Ray Amato Sr. joked to me that he had returned to the role of apprentice, shooing away flies so that the horse would remain comfortable and therefore "quiet" while being shod. The son of a farrier, Ray Sr. taught his skills to both his own son and a nephew. Today, he and his son work in tandem at thoroughbred racetracks.

Properly cared-for thoroughbred horses can lead circumscribed but comfortable lives within well-maintained stables. As ESPN commentator Paul Moran remarked in 2012:

No domestic animal is treated with more attention to detail than a racehorse, whose role in life demands constant veterinary care, nutrition, training, grooming, therapy and, in most cases, acupuncture and chiropractic attention. Their career lives are not unlike those of human professional athletes, mansions and expensive cars notwithstanding. Those involved in their development and management shoulder great expense and sometimes lengthy tests of patience. (Moran 2012)

Even with all of the minute details of each horse's care, the outcome of a race, I was told, was determined in large part by the excellence of the horse. An analogy can be made to the talented athlete who has the right combination of physical attributes and drive to become award-winning. Training assists excellence but without the initial, innate talent, an athlete will not reach the highest echelons of the sport. So too with racehorses, who can receive excellent and consistent training but never achieve champion status without a predisposition to run fast. Consistently, when asked what makes a good trainer, the response is "A good horse makes a good trainer," meaning that the only reason that a trainer is doing his job well is because his athletes are already gifted. Similarly, the rider, or "jock," can be said to have only a small part to play in the outcome. Retired jockey Dave Erb provided this explanation: "There's an old saying 'Riders don't make horses but horses make riders.' You only have to get on one or two good horses and then you're in demand. I've seen a lot of riders, real good riders who could compete with anyone, just never got that break. Just never got a good horse to ride."[2]

This belief that the outcome of a race changes little, even with continual intervention, sets up the current dynamic that to be successful with racing, one must have many horses. Today's prominently successful trainer who has hundreds of horses, is successful *because* he has many horses. With each win his profile is raised, and he in turn becomes more sought after as a trainer, thereby increasing his chances of success.

While the successful trainer at the highest level of racing is one who has enough horses to continually win and to remain in the public's eye, many horsemen mark success through job satisfaction and the ability to live comfortably, if not extravagantly. When asked what makes an ideal stable size, many horsemen replied that twenty to thirty horses were ideal. One should be able to assess and care for each horse in one's stable, each day. Those trainers who

take care of dozens of horses spread out over several states are perceived by some to be deficient in their care of their horses. For many, the ideal situation is to own and train one's own horses, thereby maintaining strict control of the training regimen and racing entries.

Training a horse is perceived as a gamble, because a single incident can undo weeks of training. It is an inexact science that demands psychological insight into animals and humans, perseverance, innovation, and luck. This occupation also requires a love for horses, long hours that begin before the sun rises and finish well into the day, and the ability to deal with both stable staff and the horse owner who wishes to realize profit from his or her investment. A good trainer needs patience, said Bonnie Bernis: "Patience. I think patience does [makes a good trainer]. A good eye. Patience is really the main thing."[3]

Renowned jockey Ted Stevenson compared the successful trainer to a coach. He said, "The trainer of a successful stable is comparable to a combination of the manager and head coach of a ball club. He has to know the idiosyncrasies of his athletes, be concerned with every ache and pain, mindful of their worries as well as their nutrition" (Atkinson n.d.). Retired trainer Dave Erb explained it this way:

Sometimes you'll get a horse and he'll just go so far. You've got to figure out why and you have to wait and figure out "what can I do to change his mind." You know there's one old-time trainer says, any dumb son of a gun can train a horse but the guy that can keep the horse at the races, that's the good horseman, which I believe is about the truth. If you just used common ordinary sense you can get a horse fit and ready to run. I think.[4]

Case argues that the highest value is placed upon trainers who are named "horsemen" by the community (Case 1984, 284). The role of horseman implies experience, knowledge, and the accompanying financial success (Case 1984, 275). Sociologist James Helmer concurs, pointing to the role of age, experience, training, attitude, and a sense of responsibility as being attributes of a "good horseman" (Helmer 1991, 183). When asked what makes a good trainer, Oran Trahan had this response:

What makes a good trainer is a man who is willing to get up early in the morning and be here early in the morning and willing to stay here as long as he has to. Because it's very detailed type of work. There's a lot of things you can do to help a horse. And a horse is demanding. You need to take care of him, you know. You can't just pay lip service. If you're going to train you have to work at it and it means

long, long hours. And in this business here you learn all the time. You learn all the time. You rub elbows with people who have different ideas—good ideas. . . .

You have some people who are just—like anything else—better at it than other people. You have people who came up and they're just good at it. They are just good at it. They're born for it and it makes a difference. If you're not willing to spend the time, you're not doing your job. You've got to be willing to be here and do your best. And after you've trained for forty, fifty years you realize, "hey I've learned quite a bit in the last forty, fifty years."[5]

A commitment to the well-being of the horse, its total care, and an empathetic understanding of its condition generally accords one the higher status as horseman, whether one is a groom, exercise rider, or pony person within the stable environment. A.J. Credeur, who went from training horses full time to training a single horse of his own, had this to say:

I kept a string of horses, twenty-five, thirty head of horses in training. I had plenty of help. When you had plenty of help and had that many horses I could get away and do things because I always had help to do what needed to be done. . . .

I scaled down. . . . Once a got my numbers down, I lost a lot of help because I couldn't afford the help anymore. And I had to do a lot myself and that's when I started getting tied down. . . . After I quit I realized how important my weekends are [laughs]. Having that time off. My famous words are . . . I never wanted nothing that's eating while I'm sleeping again [laughs]. Now I've got one that's eating while I'm sleeping and I'm back worrying again about what he's going to be like tomorrow morning. You always worry about what they're going to be like in the morning.[6]

Commitment to the care of the racehorse can be measured by one's longevity within the backstretch environment, or one's ability to understand horses and their needs. Says groom Juan Salcido Sanchez:

But it's just like I'm saying. To get to that point we go through a lot. We do many things. And it's a lot of people: the hotwalkers, the foreman, the grooms, and the vet, and the blacksmith. It's a lot of people behind the race. It's not just "win a race" and that's all. No . . . Some people . . . they care about the money, you know. They're interested in the money. To me, I'm not. I really do this job because I love the horses. I get a good pay and I'm happy with that.

But the main thing is I love the horses. That's why I do the job. If I get money that's good. That's good. But . . . I feel more happy when the horse wins. Not for the money. Just because my job is there. My hand is there, you know. That's why I feel more happy.[7]

While the trainers' expressed goal is to win races and therefore earn bonuses beyond the training fee or wage, Case contends that those who work the closest to the horses in a hands-on manner are held in highest regard. While the recipient of race earnings receives both public acclaim and monetary reward, the hands-on worker is seen as the better horseman and of higher prestige within the stable environment (Case 1984). In this instance, monetary reward is not the arbiter of prestige. Pony person Robert Paterno explained:

There are some people that think horse racing is hard on the horses and a little mean. Of course, we don't think that at all. We think they are very well cared for and we like them very much. . . . You have to like horses to do this because you spend your whole day around them. All you do is take care of them. There is a saying around the racetrack, "the closer you stay to the horses, the less money you're going to make."[8]

Jake Delhomme mentioned his father's willingness to work hard and to be involved directly with his horses in training. He says of his father, "He wasn't just a suit in the clubhouse." One's hands-on experience within the "dirty" environment of the horse stables is the basis for pride and recognition within the backstretch.[9]

Just as with other sporting activities, the contest that is the horse race includes elements of chance, vertigo, and conflict. The horse and its rider strive, during the short period of the race, to be the better "player" and to become victorious. Techniques that appear efficacious will be repeated in an attempt to repeat the favorable outcome (Case 1991). I was told of one trainer who routinely shared his best Scotch with a certain horse, believing that it made the horse run faster. Other trainers might use magnetic blankets, deep tissue massage, or other techniques such as specially crafted salves for sore legs and feet. At training facilities, whirlpool baths are used to ease tired muscles and joints. More unorthodox interventions are carefully guarded secrets. Trainers are warned not to practice veterinary medicine; the use of medications are highly regulated and can only legally be dispensed by a licensed veterinarian. Any infractions of the strict rules governing accepted treatments can lead to censure or loss of one's training license. However, salves and liniments are sometimes

concocted in order to provide relief to tired legs and feet. Groom Bonnie Bernis attributed her knowledge of poultices and liniments to the training expertise of her father:

> I had a filly that had bad feet and [my father would] tell me some kind of stuff to use. It was a combination of a medicated mud, a poultice with bran, Epsom salt, and the ichthammol,[10] which is a black drawing salve which is a combination of all of that stuff. You use that as a drawing to get the heat out. That was pretty good . . .
>
> The old timers, they made their own medications. Now they buy everything. I don't think that's so good. Like when my father trained, he'd use like cucumbers, stuff like that for cracked heels. Now they've got all those salves and stuff. I mean it does the trick but it takes so long to do it. With the cucumbers and whatever stuff he'd use, in two or three days it was gone.[11]

Retired jockey and trainer Angel Cordero, in talking about his family's involvement in racing, offered this:

> The only thing you can work on their legs. Everybody got their own paint to paint horses if they got problems To poultice, to ice them—work on the legs. That you can

do yourself. . . . Everybody paint horses . . . keep their legs tight. Working with a lot of different trainers for so many years. So you learn but everybody does it to some remedy. People use different kind of mix to paint horses. Whatever they have success under they stick with.[12]

Dave Erb spoke about the importance of the blacksmith[13] in finding a solution for cracked hooves, and the ingenuity that is used to find a solution to a problem:

> Years ago when a horse got a quarter crack—a quarter crack is a separation in the hoof . . . in the weakest part of the hoof—There was a fella by the name of Bill Bain. He was a blacksmith out in California. And he had been working on this, some way to protect the horses hoofs after he'd got a quarter crack like this. And he finally got a hold of a solution that would make a piece of rubber stick on a horse's hoof. It took him five years to find out something that would stick on a horse's hoof because actually nothing will stick on a horse's hoof you know. So he would use a Neolite sole like you use on your shoe. And he would put that on the patch. And it would take him a good three, four hours to get that. To trim that foot and put that patch on.[14]

Trainer Cleveland Johnson attributes Hall of Fame trainer Woody Stevens (1913–1998) with the saying, "You can't train what you can't see."[15] This style of training relies on small stables with fewer than forty horses, a small staff, and a hands-on training style in which the trainer visits each of his or her horses within a day's time. This model of stabled horses within one stable most likely had its origins in an eighteenth- and nineteenth-century horse racing model, which relied upon a wealthy patron with several horses employing a trainer to oversee his operation. This model was employed both by family dynasties such as the Wideners of Elmendorf Farm in Kentucky, and by large racing operations such as Hurricana Stock Farm (later Sanford Stud Farm) in Amsterdam, New York, and Dixie Knight Farm in Kentucky, both owned by carpet magnate General Stephen Sanford and his sons, John and Will. As stated by the Sanford Stud Farm's historian, Louis F. Hildebrandt Jr., General Sanford's passion for the sport was not driven by money "but rather by the enjoyment that he derived from watching his horses run, 'to see their colors go to the front'" (Hildebrandt 2009).

Horse racing, and its status as a hobby for only the very wealthy, began to change appreciably in post–World War II America. Until then, horse racing and thoroughbred horse ownership was predominated by those who had a passion for horse racing and the means to enjoy the sport with little regard for the income realized through the winning of races. This began to change during the 1950s through 1980s, as a rising middle class found the time and disposable income to attend and bet on horse races. As attendance and earnings at race meets rose, so did the interest in horse racing as a business endeavor. Owners found that they could turn a profit from horse racing, and middle-class enthusiasts saw that they could pool their resources as a "syndicate" to own a horse or his breeding rights. By the early 1980s profitability was at its all-time peak. Horses that might have been valued in the thousands of dollars during an earlier decade were now valued in the millions (Ferraro 1992).

Similar to the corporatization of other professional sports in the United States, horse racing in the latter twentieth and early twenty-first centuries became more work than sport. While participation due to intrinsic rewards remain, horse racing (as with other professional sports) has experienced a rising importance of monetary rewards, an increase in performance-enhancing drugs, and the association of success with outcome goals of profit and visibility (Frey 1991). During the latter part of the twentieth century, the structure of racing and race meets also changed at the state level. Because of the interest by states' governments to reap maximum benefit from the economics

of racing, racing began to become a full-time, year-round enterprise. A state such as New York can now hold meets at Saratoga through July and August, followed by racing at Belmont racetrack through October, to be followed by racing at Aqueduct, then racing again at Belmont, beginning in May, for a full-year racing schedule. Thoroughbred horse racing is year-round with no off-season (Ferraro 1992). Says trainer Oran Trahan:

> I've been doing this on a professional level over forty years. I started in the late sixties and I made a living out of it. I did not get rich but I made a living. I was able to support my family, send my two daughters to college, you know. And I'm still doing it, you know, but I'm satisfied. I stayed home. Ran mostly here and some in Texas some in Arkansas but I stayed here. I didn't venture out somewhere else, Kentucky or Florida—places like that. But you need to do that if you're really going to do BIG in this business. You take the big guys in this business . . . they're always on the run. They're always on the run. The horses own you. They OWN you. You're always travelling for a horse and that's the way it is. It's very, very demanding.[16]

As a result of this inflationary trend, horse racing and the attitudes toward stable size changed appreciatively in the 1980s. Where once a single trainer was expected to oversee the training regimen of up to forty horses, the organizational model changed to one with hundreds of horses spread over several states, employing assistant trainers and stable workers for coverage throughout the United States. The initial change in management structure is reported to have been introduced by D. Wayne Lukas, a Thoroughbred Hall of Fame trainer. In an interview with *Business Week*, Lukas states, "We changed the game. . . . we said, 'Let's develop a program in which every horse will be successful. If he can't run at Santa Anita and Saratoga, we'll drop him into Monmouth Park. If not Monmouth Park, we'll drop him down to Delaware. If he can't compete in Delaware, we'll take him to Omaha.' And you know what happened? All kinds of records fell. We stated dominating across the country" (Kirby 2004: 52). A fellow trainer says this about Lukas:

> Wayne Lukas probably changed the business. He came around and decided he could train in multiple states in multiple divisions. He hired very, very smart young men—taught them what he wanted done.
>
> And way back people didn't think you could do that. They thought you had to be right there yourself every day, but when he came along and he would instill his work ethic and his ideas of how to train a horse

into his son Jeff, into Todd Pletcher, Kieran McLaughlin, Randy Bradshaw, Mike Maker, and then put one in Chicago, one in New York, one in Florida, one in Kentucky, himself in California . . .

And when he started doing it and then people that left him did it and they got more organized and probably turned it into a little bit more of a corporate business. . . . It's a different model.[17]

This stylistic change in horse training and horse racing reflects a twenty-first-century shift in the United States from an agrarian-based economy to one in which less than 15 percent of the population is involved in farm-related activities. With this shift, the horse—previously an important part of both farming and transportation—has been transformed into a companion and sporting animal (AAEP Racing Task Force 2008). It is generally believed that the corporate model of horse training has had a severe impact on the abilities for new, up-and-coming trainers. An aspiring trainer had this to say:

It [training] changed around '83. . . . In my opinion it changed for the worse. . . . People used to take their time with their horses. Now everything is rush, rush, rush. You have certain trainers bringing horses to the gap. The rider jump off. He jump on the horse, gallop him. Bring another one to the gap and jump on. Before they used to take their time. Now it's just not the same. . . . Some people have [so many horses] and some people can't have one. A trainer can't oversee. I don't care who you are—A trainer cannot oversee a hundred horses. You can't do it. You can't do it. But that's how it is now. And you have some good people who don't have opportunity. You know, if they can just take and give some people, I know some good people who know what they're doing but if you're not connected or look a certain way then you don't get the opportunity. And that's just it. That's just it.[18]

The new emphasis on larger stables has been likened to Walmart. Said one successful trainer:

"Right now I have fifteen horses, right now. That will keep you busy. It's like everything else, you know. The big ones are getting bigger and the little ones are going out of business. Like with Walmart. They come in and they get bigger and bigger and the little ones are going by the wayside. Hundreds . . . they[the big trainers] are the Walmarts."[19]

Trainers with smaller operations, or new trainers just starting out, are felt to be at a disadvantage in this corporate model of training. This advantage by the larger stables was

detailed by a Saratoga-based exercise rider: "You don't know half of it with the bigger trainers. They have such a turnover. They've got such an overflow that they can just keep turning the wheel, turning the wheel. You get the smaller trainers that have to try and keep them as long as they can because they don't have anything to follow up."[20]

Current horse racing has its critics within the circumscribed universe of the backstretch. Those who work daily with horses realize that the focus on race outcomes has had a generally negative impact on the sport. Riders point to the new surfaces of racetracks as having deleterious effects, and complain that horses are not given enough time to heal from injuries or to rest after a strenuous race. With the emphasis on year-round racing and the profitability of a racehorse to an owner, horses are not provided ample opportunity to rest between races to allow injuries to heal (Ferraro 1992). Riders who interact daily with the horses rely on the horses' health for their own longevity within the thoroughbred horse industry. Says exercise rider Lorna Chavez:

> So you end up something happens to your horses and you have to get rid of a groom or a hot-walker. And they don't have a job and it's not their fault.
>
> You've had to try and do something because it's what your owner wants. And if you don't do what your owner wants the owner's going to give it to someone else who will do what he wants. But you might not ever hear of the horse again. It's very Catch-22 . . . a racehorse is a racehorse and it's running.[21]

Those involved in thoroughbred racing also complain that current breeding practices have changed the makeup of the horse. Once bred for strength, the thoroughbred racehorse is now bred solely for speed. Lorna Chavez reflected on the changes wrought by selective breeding: "Horses are so different now. Back in the day they were like much stronger built. They were bigger horses. They had more stamina. Now they're bred to be nothing but speed, speed, speed. That's all they want. They want the fastest horse in the world. They want the fastest racetrack in the world. You know. Which is crazy!"[22]

Riders, including Chavez, expressed concern regarding the sustained speed of racing and the effects that speed has on the health of the horses: "I don't know why they have to have speed. I mean, does it really matter that they go so, so fast? Can't they just have a race where they run, and that's it? We just run and that's it? They get upset if they don't go fast enough. Don't they know that speed kills? At the end of the day? And horses don't last. They don't last."[23]

Exercise rider Calvin Kaintuck says he has a "clock" in his head. Riding since age fourteen, the eighty-three-year-old Kaintuck has seen the current sport focus more and more on speed. He says that a horse today runs a few seconds faster than it did seventy years ago because of the surface of the track. That's why, says Calvin, horses break down. There is nothing to hold them back. Current tracks have a hard base so they last year round. As in running on any hard surface, the tracks sting the horses' hooves and legs. As a result, the horses run with less comfort and with more likelihood of injuring knees and legs.

Horses are also being trained to run at younger and younger ages. The American Association of Equine Professionals points out that the corporate or business model of racing relies on two-year-old horses to begin competing at the end of their second year, reaching their maximum earning potential as three-year-olds. The association cautions, "There is a need for continued investigation of the welfare and safety implications of current policies and procedures employed to sell, condition and race two-year-olds" (AAEP Racing Task Force 2008).

Advances in veterinary science, which were developed in the latter part of the twentieth century to alleviate a horse's suffering through injury and to assist in the healing process, are now being routinely used to prolong a horse's activity on the racetrack. A thoroughbred racehorse being worked on a year-round schedule of race meets can be given treatment for an injury to allow it to return to the race course before that injury is sufficiently healed. In effect, the use of narcotics and painkillers can allow that horse to compete just one more time, moving the use of veterinary medicine from "the art of medical treatment to the craft of portfolio management" (Ferraro 1992). Said groom Juan Salcido Sanchez:

A lot of things behind the race—and the more important things are behind the race. The race is more than these things because it is just two minutes, and that's all. I always say, when somebody asking me, "How do you feel about the horse in the race? Are you going to win?" And I always say, "The only thing that I need to win the race is two minutes of lucky and first, God."[24]

Chapter 6

Two Minutes of Lucky

Concepts of luck are frequently articulated in conversation and within more formalized proverbial expressions in the backstretch of the thoroughbred racetrack. Certainly the idea of competition is part of the *raison d'etre* for the horse racing industry; however, a generalized worldview that expresses the significance of luck, chance, and risk is shared by many individuals in the backstretch. The idea that "Anybody can get lucky in this business" engenders an atmosphere of potentiality and possibility. Sociologist James Helmer writes, "The horse undergirds the backstretch economy, perpetuates a level of mystery that allows superstition and magic to exist alongside sophisticated technology, frames experience and shapes the sense of time, structures interpersonal relations and maintains a class system, and seduces people, bringing them both pleasure and pain" (Helmer 1991, 194).

The act of betting on horse racing has historically been part of the social milieu of racing. In the eighteenth and early nineteenth centuries, localized horse racing took place both in the United States and England in the form of a match race, a one-on-one race in which two horses and their riders vied for the distinction of winner. Match races most often were situated in a locale and were attended by friends and families of the contestants. They were predominantly "local events attracting a local audience" (Itzkowitz 1988). In the United States, historians of early racing have depicted the importance of the "match race," especially when it was a contest between specific horses who represented regional divisions in the United States. In the formative years of the Jockey Club, between the years 1822 and 1845,[1] a series of "intersectional

Loading horses into starting gate, Saratoga Racetrack, 2012. After being ponied to the starting gate, each horse is place in one of the chutes. Starting gate attendants, pictured here, help place horses in position.

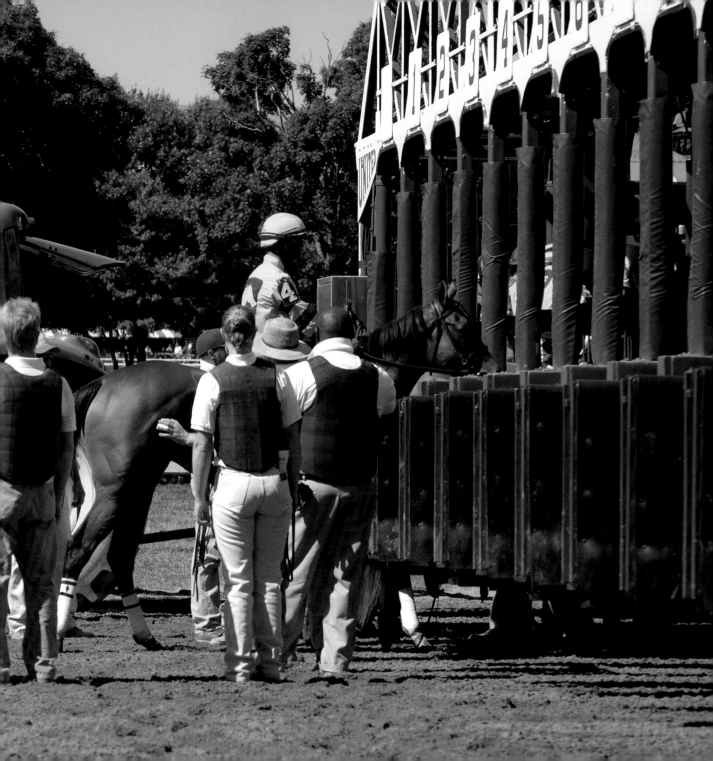

contests" took place that pitted a Northern favorite against a Southern leader. These match races were designed to launch the rebirth of the sport of horse racing for Northern audiences, and took place at the Union Course in Jamaica, New York, then the center of racing in the North (Riess 2011). The first such race on May 27, 1823, pitted the Northern favorite Eclipse against the "Southern Stallion" Sir Henry in a series of three heats, after which Eclipse was declared the winner. The audience for this famous match race included then-Senator Andrew Jackson, an avowed horseman, and former Vice President Aaron Burr. Match races such as this one included betting on the outcome of the race; in this instance the "handle"[2] was a million dollars (Riess 2011). During this early era of horse racing in the United States, heavy betting was mostly confined to a small circle of "racing men," horse owners who bet to add to the excitement of racing or to assist in supporting their racing hobby (Itzkowitz 1988). Nineteenth-century horse racing, and its attendant betting, was the domain of the wealthy who had the disposable income and associated leisure time to participate in such agonistic displays.

In his seminal treatise on sport *Man, Play and Games*, Roger Caillois identifies the four elements of play: *agon* or contest, *alea* or chance, *mimicry* (simulation), and *ilinx* (vertigo). In looking at ancient Greek society, Caillois recognized the concept of luck, ascribed in a priori fashion as one's destiny. This concept is in opposition to merit, which is earned through the acquisition of skill. The combination of competition and chance, skill and luck are characteristic of games. Games of chance delineate the prospect that "anyone can win," and the hope of winning is what allows games of chance to prosper (Caillois 1961).

The hope of winning is a concept that permeates the thoroughbred racetrack. Trainers mitigate the element of chance through examining the competition and making an educated judgment as to the possibilities or "odds" of doing well within a specific race of a field of contenders. However, the outcome of any specific race cannot be predicted and can be variably affected by weather conditions, the field of contenders, the circumstances occurring within the running of the race, and any number of physical factors of the jockeys and horses entered in the race.

While chance is certainly an element for those involved in the participation in a race meet, chance and luck are also factors for those who are spectators of the race. The thoroughbred industry exists and thrives because of popular interest in games of chance, and playful behavior that such interest elicits. Martin McGurrin, Vicki Abt, and James Smith, in their article "Play or Pathology: A New Look at the Gambler and His World" (1984), study

the motivating behavior of gamblers and find that, as a generalized group, habitual gamblers are more likely to hold a fatalistic orientation to life and are more likely to believe that individuals can be "born lucky." They conclude that the gambler "simultaneously entertains himself through the patterned experience of excitement, suspense, and release," creating "an acceptable pattern of temporary escape from the restrictions and limitations of real life" (McGurrin, Abt, and Smith 1984, 93–94). A further motivation for gambling within the arena of horse racing is the allure of the intellectual exercise (Smith and Preston 1984). In placing a bet, the experienced gambler can study the individual horse's records, the jockey's statistics, and the trainer's credentials to arrive at an educated guess as to the race's outcome. Such motivations for gambling do not just apply for the player of games of chance; at the racetrack, it is also true for those who provide the players for the "game" or race, as the trainer makes strategic decisions regarding placing a horse within a specific race. Said A.J. Credeur, general manager of the Evangeline Training Center:

This is a condition book. . . . You can look at a race in there and they'll have the condition of the race and the class or whatever. If you follow the races enough you'll know what horses are going to be in that race. So it gives you an idea. If you learn the game enough you'll know exactly what.

If I go in this race, here, I'll hit with this horse, this horse, this horse, that horse. I don't think these two horses I can beat. I may finish third in that race. So you look on and find another race that they might not be eligible for that YOU are. Where you can possibly win. It's all strategy. It's what it's based on. It's a technique. I lost all of my hair thinking about it [laughs].[3]

At the racetrack, hard work is rewarded. However, hard work is often not enough to win a race. The successful stable involves hard work and that element of chance that results in a trainer's being offered good horses to train. In the course of multiple interviews, the concepts of luck and chance were mentioned as being at play within the race environment. George "Rusty" Arnold, a seasoned trainer headquartered in Kentucky, had this to say:

There is an element of being lucky in two or three different ways. Sometimes you have to be lucky to get the horses in your barn that can run. It might be meeting the right person, being in the right place at the right time, being introduced to the right person. Because no matter how talented you are if you don't have horses with talent you can't do well in this business. I'm

not saying you can't help a horse, you can't make a horse a little bit better, that one trainer can't do a better job than another one, but without a talented horse you can't make them talented.[4]

Saudi Burton has variously worked at the racetrack as a groom, an exercise rider, and an assistant trainer. In 2013, she was working for the New York Racing Association as a "gap attendant," monitoring the horses and timing their morning work-outs during the Saratoga Race Meet. An African American woman, she is trying to break into the role of "trainer," and she concurred with George Arnold's perspective on "luck."

"It's mostly luck and connections. If you don't know nobody you're not that lucky. You don't get it. But if you know people and you know connections. It can happen most any kind of way but mostly luck and connections. It's who you know, not what you know. There's a lot of that in the horse racing business."[5]

Retired jockey and trainer Dave Erb concurred: There's no limit to what you can do if you're lucky and get a good horse.[6] A groom said this about trainers: "I just think you've got all these young guys and stuff and they didn't come up underneath anybody. They just got lucky."[7] And Hall of Fame jockey Angel Cordero mentioned luck as being important to success: "Good horses, good owners. Good horses, good owner make good trainers and good jockeys. A lot of dedication and a lot of hard work and try to get lucky."[8]

Notions of luck are predicated on ascribing value to an event after its occurrence. In analyzing an incident, the examiner will look to the sequence of events or actions which transpired to determine causation. The assignation of luck is an "a posteriori look at the event" (da Col 2012, 6). Sarah Camele Arnold, who began working at the racetrack as a groom and then as an exercise rider, provided this explanation: "Luck is a big part of the business. Sometimes you'll have the best horse and you'll get caught on the rail behind another horse and someone else will win. Sometimes you get lucky that way, another horse will get trapped and you'll win."[9]

Horse racing is a risky business. The purchasing of a horse—investing large sums of money for a living animal who is subject to injury or illness—entails risk. Similarly, investing in a young animal for the chance that it will prove to be a contender is a step into an unknown future. Tom Luther, a jockey who was instrumental in the formation of the Jockeys' Guild, spoke about the financial risk borne by trainers: "I think you have to be lucky riding too, but the trainer, you have to be lucky. You have to be. If you pick up a horse and claim him. Well, he don't have to be a perfect condition. He can break down in a race. You invest five or ten thousand in a horse and he breaks

down in a race then you're done and it's a gamble all the way through."[10]

Beyond the financial risk, the element of physical risk is ever present for those working in the stable area of the racetrack. Jockey Gary Stevens wrote, "I learned very early in my career to basically live day by day . . . and never try to predict the future" (Stevens 2002). A horse can suddenly react to a sudden noise, a bird in flight, or a piece of debris blowing in the wind. A horse can lose its rider during training and gallop erratically and unpredictably on the track or in the stable areas. Former jockey Bill Boland ascribes being "lucky" to his ability to ride as long as he did without serious injuries: "I was lucky. I only broke eighteen bones in twenty-one years. I never got hurt too bad. Most I was ever out was six months."[11]

Narratives of accidents and incidents in the backstretch are freely shared as examples of the attendant risks of the activities. Exercise rider Ellen Loblenz spoke of one such incident: "I was supposed to ride my race back February 26 and on February 23 I was at Boston and a piece of newspaper come on the race track and got caught between my horse's legs and I fell off of her and she ended up tripping over me. So we pancaked."[12]

The element of chance that is experienced in the backstretch of the racetrack transcends the actual race itself, the culminating event to what might be weeks of training. This culmination can be affected by any chance event at any time: a pebble is kicked up, a horseshoe is thrown, a saddle slips. Any of these seemingly minor events may lead to a chain reaction in which a horse becomes unfit to run. For Loblenz, who already had riding experience on the horse-show circuit, becoming an exercise rider required a substantial period of learning new skills:

So, my first day. This is a funny story—talk about persistence. It had been raining for five days straight. The first horse I got on ran off with me. The second horse bucked me off. The third horse . . . they [the exercise riders] tack up their own horses . . . In the show ring [where I learned to ride] you do everything very slowly. You groom the horse and put the saddle pad on and then the saddle. Then you put the girth and you put the martingale on. These riders [at the thoroughbred track] tack up in about a minute and thirty seconds and they were getting very flustered that I wasn't. It was on the farm and they had two hundred horses to get out and you have to keep rolling to get the job done. Somebody helped me tack up the horse. I never checked my girth. I went to turn around and mfttt . . . [she demonstrates with her hands that the saddle has slid

underneath the horse's belly]. The horse that the saddle turned over was probably worth $60,000 and with the damage done with the saddle it sold for $10,000 and never raced.

Interviewer: Because of that one incident?

When the saddle flips over the stirrups are hanging down and they totally, totally destroyed the horse's knee.[13]

Those who work with horses can find in an instant that they have fallen prey to a highly dangerous and volatile occupation. Groom Bonnie Bernis remarked on the dangers found within the backstretch:

Yeah, they get loose all the time. Had a couple get loose. One was . . . really bad. And he got loose about where he is [gestures to a fellow groom] and he went running down the street and there was a guy with a pony. Oh, that was like a major thing. He was trying to get on top of the pony. But oh God.

Everybody comes out and tries to block it off and stuff so we caught him but it's still not fun. A lot of people try and run out in front of him and try to stop him.[14]

One exercise rider was thrown from his horse during a morning gallop, breaking ribs and leaving him unemployed for the remainder of the year. A groom experiences a broken foot after being stepped on by a horse and is also temporarily unemployed. Unemployment can have serious ramifications in this world of contractual employment, and there are gross inconsistencies between different states' regulations and laws. In New York State all stable employees (stable hands, exercise riders, and jockeys) are covered through worker's compensation insurance, which is required to be held by trainers headquartered in the state. Only three other states—Maryland, California, and New Jersey—have similar worker's compensation policies (Barker 2013). According to the Kentucky-based Jockey's Guild, one in five jockeys are injured each year, and even when tracks provide insurance coverage, there is no long-term care (Barker 2014). Other states have not been as generous, stipulating that exercise riders are independent contractors who must carry their own insurance (Allen 2003). As Jerry Bailey, longtime jockey and former president of the Jockey's Guild, has said, "It's the only sport that I know of where the ambulance follows you when you do your job" (Barker 2013). Outrider Bob Paterno spoke of the necessity for the outrider to be vigilant for impending trouble and to be able to react quickly and correctly: "We have a saying. Rule number one, don't panic. Rule number two, never forget rule number one! You have to

think your way through what could be a dangerous system and you have to think fast."[15]

In such an environment, fear is often a factor. Groom Juan Salcido Sanchez spoke of the learning he experienced under the watchful eye of his father:

The first day when I start to work with the horses, my father, he never told me nothing. He got a bad horse. He was a tough horse to work with. He was very wild. My father, he don't tell me nothing.

He just tell me, "Hey, go inside the stall and take the bandage off the back horse." So I don't know the horse. I don't feel afraid. I go straight to the stall and took off the bandages. The horse, he don't do anything to me. He was very quiet. Then when I came out, my father tell me, that horse was the baddest horse in the barn. He bite a couple of guys. He kick a couple of guys.

"You wasn't scared?"

"No."

Why? Because you don't know. So that is the way you have to do the things. Don't be scared. Now, he tell me then, "Now, go in and do the same thing." And I say "NO."

You see? He tried to teach me. You know, you see? Sometime the people don't even know the horses and they are very scared. So that is why I tried to teach them

little guys. You know. Don't be scared. The horses are not going to do nothing.

The horses are very sensitive about everything. And sometimes the horse is like playing with you. He is like try to scaring you. He is like, "OK, I'm going to do this thing and try to see the reaction of this guy." And if you get scared, the horse is going to do that again and again and again. Because he knows that he is bigger than you and he knows that he can bite you, that he can kick you. And he knows that you are afraid of him. So they are very sensitive. So if the horse tries to kick you and you don't get scared and you show yourself and say something and things like that—the horse learns. And the horse, he understands and "okay, this guy is more smart than you," and then calm down. He is a very sensitive animal. Especially the fillies are more sensitive—like the women [laughs].[16]

The ritualized routine within the stable of thoroughbred racetracks is an effort to minimize risk. This pertains also to the regimented system of procedures imposed during the morning workout sessions, the time during the day when the horse is able to leave its stall and stretch its legs. Because of the change in routine and the increased level of activity around the training track, the horse is most

excited coming into and leaving the training track. Riders entering the racetrack oval for training purposes need to be aware of those already exercising on the racetrack, and also aware of those horses and riders entering and exiting. Perhaps no instance is riskier than the moments of entrance or egress from the oval training track, which is used by every horse in a backstretch area or training facility. This gate can prove problematic as the horse may react negatively or positively to entering the stream of activity. In addition, during peak training hours, dozens of horses are sharing the racecourse, all with different training regimens. However, collisions are seldom, owing to the regimented systems in place for the training period. In the role of outrider, it is one of Bob Paterno's tasks to make sure that everyone is moving in an acceptable direction and pace around the track:

> At the racetrack we have different lanes too in the morning for the training. The fastest horses go on the inside. The "workers" we call them. They are going as fast as they can run. They have the inside lane. Then a couple lanes out would be a fast galloper. And then the regular gallopers and then ones who are just ponying[17] on the outside. And everyone coming back to get off the racetrack would be going the other way and they get the outside part.[18]

Exercise riders who get on multiple mounts each day have their share of accidents. Perhaps because they are in the situation of schooling horses who may not be used to the racing environment, these riders perhaps are the most in harm's way. Accident narratives abound among this occupational group, as riders relate instances where they escaped severe injury or death.

Tommy Luther started riding horses in 1925 and continued as a jockey for the next twenty-six years, then took on the role of trainer for another twenty-six years. Because of the accidents and dangers he witnessed at the racetrack, Luther worked hard in 1939 to establish a fund for injured and disabled jockeys. He related this story of a fellow jockey's mishap during an interview in 1995:

> This happened in Bay Meadows, California. He [the jockey] had a bad fall. And, matter of fact, he went to the hospital. They gave him up as dead. They sent him to the morgue and . . . waiting for the undertaker. So now all he's got is one boot on and a sheet over him.
>
> It passed on. It got dark and he had woke up. Come to. Got up off the table. Wrapped the sheet around him, went out on the road and hitchhiked a ride. It's a true story . . . That was 1936 and so he come back the next day to ride and they

wouldn't let him ride. He was supposed to be dead. It's a true story, so help me God. And I was there.[19]

Exercise riders cite the importance of mitigating risk through routine activities and a regularized way of conducting themselves during morning workouts. Riders are regularly accompanied by trainers or their assistants to supervise the workout—both for the purpose of gauging the health of the horse but also to assist with any problems as a safety mechanism for the riders. Working the horses in a "set," with several horses entering the track at one time, helps provide a support group for each rider. Said Ellen Loblenz:

The next horse I got on was absolutely wonderful and I was supposed to go in company with a horse and we pull up and the horse was in front of me and the horse was ducking and spooking and carrying on.

God I'm so glad my horse is good.

The exercise rider says "What are you doing!?"

"What do you mean?"

"You're supposed to be in company with me!"

"I'm right behind you."

"You're supposed to stay right next to me the whole time."

I was like, "oh."[20]

A horse and rider enters the training track through a narrow gate that is merely a hole in the fence or, as in the use of a "chute," a more defined passageway through which the horse has to navigate. In entering the training track, the horse has an air of anticipation as it realizes the opportunity to stretch its legs after twenty-four hours in a narrow stall. Biologically a herd animal, the horse recognizes its fellow racers and knows that it soon will be in the middle of the thundering pace of multiple horses moving around the track at breakneck speeds.

Leaving the track is similarly risky. As a creature of habit, the horse knows that the routine of training is frequently followed by a morning meal. Upon exiting the training track, the horse is anticipating the grain that is waiting for him back in the stall. Navigating the gate can be tricky for a rider, as mounts are both entering and exiting within close proximity to each other. If one balks at the fence, the resulting backup can cause a dangerous situation. Sometimes, accidents happen because of a malfunction of riding equipment, or the horse can slip on a wet or uneven surface. Rider Calvin Kaintuck spoke of one particular incident:

I was working for a trainer. . . . He had a weird habit of telling me at the last minute of telling me what to do, what he wanted to do. But this time "you're going

to just jog this horse." So when I got out there jogging the horse, he said, "Meet him over by the gate." I thought, nothing to it. Still in a jog. But the girth was a little too big. (I'd been preaching to him all the time, "you need smaller girths, smaller girths." Or "have some shortened." Horses start at springtime they're big and fat but as they get into condition they get smaller, get tighter.)

I went to the gate. Then he told me "gallop around the gate" [laughs]. So I did. When she came out of the gate the saddle slipped.

Now when I went that side I'm pulling it back. (I can usually stay in the saddle pretty good.) I'm still twisting it, trying to get it back. And I had to take my feet out of the irons. And I'm still twisting, twisting, trying to get right side.

She's running now. All the way down the stretch. When I get down, going in to the turn (like you see the horse run to the end they start slowing up), she kind of slowed up a little bit and I thought I could jump off and hold the reins and run up beside her. The minute my feet hit the ground I did a complete somersault right on the back of my head. Oh, I saw stars! So I went home.

The next morning my pillow was full of blood. So I went to the doc, he said, "you

had a concussion." Yes, that's what happened to me so I said the helmet saved me. Yep. That's twice I got saved by a helmet, I said to myself. I believe in them. You can't take it off me.[21]

Risk, the embodiment of uncertainty, is present whenever the outcomes of any action are not assumed. Risk taking is generally viewed positively in American society (especially if the result is a successful outcome), and is considered an integral part of the culture of sport. This is especially true for extreme sports that transpire at high rates of speed and place the participants in danger of injury or death (Schneider et al. 2007, 332). Borrowing from Richard Raspa and his work on injuries among athletes, riders on the thoroughbred racetrack enter a deeply focused engagement with the thing at hand, which is the "ride." They exhibit a willingness to "push through denial, fear, and pain, to be present to whatever is there" (Raspa 2010). This phenomenon of "being entirely focused on the activity at hand" has been well-documented by Mihalyi Csikszentmihalyi, who has named this state of total concentration "flow" (Csikszentmihalyi 1975).

Riders, however, can cease to be effective when they realize their own vulnerability and become fearful for their own safety. A rider is said to lose his nerve. Seasoned rider Lorna Chavez reflected on that moment: "A lot of

people . . . They might be losing their nerve a little bit. Like starting to get a bit scared of the horses and then when they do something wrong—they hit them or get angry with them, which doesn't help either or because then they jump and then you get more scared. I think there's a lot of people that maybe ride for too long."[22]

For some, the inability to achieve a flow state may be caused by anxiety for one's health or the health of others, recognizing that life-threatening accidents could happen at any moment. For others, this occasion is when one realizes that others are depending on them, as in Ellen Loblenz's realization that she was going to become a parent, putting an end to her dream of being a jockey:

> *I did ride races. I was an apprentice rider. . . . And that was when I found out I was going to be a mom. . . . The horse stepped on my knee as she went to get up. So my knee was like this huge. And they wanted to check my urine for blood and the girl said, "any chance you could be pregnant?" . . . I went to move down to X-Ray. "Wait! Wait! You're going to be a mom!" . . . But that sort of changed my career plans.*[23]

In a study examining risk taking and adventure seeking, Schneider and her colleagues at San Jose State University identified three coping strategies that emerged from their interviews with elite athletes—those who participate in high-energy sports with substantial elements of risk. The first theme regarding preparation by the elite athlete is that of negotiation, in which the athlete weighs the risks and calculates the odds for successful conclusion of an event. Prior to an event or context, he or she reviews the potential outcomes on a spectrum from successful conclusion of the competition, to personal injury, to death. Questions such as "What are the potential outcomes?" "What has been the experience of others?" and "How do my skills and experiences compare?" provide an internalized discussion regarding risk perception. The second theme is coping, in which the athlete develops a set of behaviors or attitudes that help him or her manage the psychological stress of competition. These include normalizing the idea of injury as a natural occurrence for the activity, and risk regression, in which a person gives up the dangerous activity after observing another's accident, returning to the competitive arena at a later time. Following Alpert (1999) in his study of cycling, Schneider et al. acknowledged the rationalization of injury as being a standard part of the sport, thereby potentially diffusing the role of the threat of injury as a deterrent to continued participation (Schneider et al. 2007, 349–50) The third strategy for the elite athlete is visualizing the event before

its beginning to mentally prepare for the challenges at hand.

Coping strategies are part of the regular conversations of racetrackers. For example, negotiation—the weighing of risks and the calculation of odds to manage psychological stress—is present in the conversations regarding the use of safety equipment. In more than one narrative, Calvin Kaintuck pointed to the importance of wearing the required safety gear as a way to cope with the dangers experienced by exercise riders:

> *I went down on the rail. On my head with the helmet. I had a gash in that helmet I could put my hand in. At first off I was cursing the helmets: "You don't want all this jive. . . ." But after that you couldn't put me on a horse without the helmet. . . . I hurt my knee but I would have hurt my head. I would have been in trouble I think if I didn't have that helmet on. I believe in it from then on.*[24]

In some cases, beyond the acquisition of the proper skills, there is the expressed belief in a higher power to assist one in this dangerous activity. When speaking of her several years of training as an exercise rider, Ellen Loblenz spoke of God as a source of protection: "But for me to become an accomplished exercise rider it took me a good five years. It took me

a good five years. At that time I was very, very fit. I had absolutely no fear. I acquired a lot of skills to deal with difficult horses. I could pretty much get on everything and God watching over me we could get the job done."[25]

Others point to the help of others, or the work of the outrider, who functions as a combination traffic safety officer and security guard. The outrider serves in a guardian role. He or she is there to make sure that every rider is wearing safety gear and wearing it correctly. He makes sure that riders are not under the influence of drugs or alcohol, and that they are riding responsibly. For the most part, however, they are there to assist riders with dangerous situations, to catch and calm a runaway horse, or to intervene if someone is experiencing and difficulties or hazards. Sarah Camele Arnold spoke about the outrider as being an important part of racetrack safety:

> *I decided that I wanted to learn how to be an exercise rider. They put me up on a horse; you have to go through this whole approval. They have the outrider watch you and make sure you're going to be safe and he decides that.*
>
> *And it was really funny the first horse I got on.*
>
> *They took me out with a pony and showed me where the poles were and what I would need to do and they would*

be down at the one end to catch me. The horse was perfect until we got to the corner pole and then he realized "this person doesn't know what she's doing!" So we were [makes a "fast" noise] so it was good that the outrider was there to catch me.[26]

When asked about the risks at the racetrack, outrider Ben Buhacevich spoke of an incident that had happened that morning:

This morning, the boy stripped his bridle off when he come off the horse. . . . The horse propped real quick and spun out from under him backward. And the boy kept going straight and, as he was going by, he reached out for the bridle and he took it off with him. You have no chance of catching one that way. . . . He was going pretty good . . . Without a rider on them they just run wild. For a lot of horses their confidence is the rider, and when they lose them sometimes they just don't where they're going or what they're doing. They definitely panic.[27]

Normalizing injury is a verbal strategy of those who work with thoroughbred racehorses. Every rider can relate a story regarding an injury received as part of the regular routine of exercising horses. Experienced riders can point to multiple broken bones and can state, as former jockey Bill Boland did, "I was lucky. I only broke eighteen bones in twenty-one years. I never got hurt too bad."

Chapter 7

The Language of Belonging

The worldview of the backstretch is made apparent through the specific vocabulary used by those within the backstretch, by the colorful use of idiomatic and proverbial expressions, and by the conversational shorthand of meaning made possible through shared experience. Similar to the inside language used by occupational groups, the language of the racetrack provides a shorthand so that those who share an occupational niche can converse about matters of mutual concern with the recognition that some details are not needed. The language also demarcates group inclusion and can obfuscate meaning for those outside the occupational circle.

The use of specific forms of narrative folklore has been studied within many different work environments.[1] Regarding the use of narrative genres within occupational settings, Robert McCarl states, "Occupational expression is inextricably linked to the work processes and micro-environments in which it functions, and therefore the study of these processes demands a comprehensive view of the relationship between the forms of communication and the environment in which they occur" (McCarl 1978). McCarl identifies oral, technical, and gestural modes of communication within the occupational setting. However, he acknowledges that verbal communication still predominates. Says McCarl about the occupational setting, "Stories about first days on the job, accident and unusual occurrence accounts, jokes, jargon, the use of nicknames, bull-shitting, ragging, and stories about particular characters and individuals are common topics of verbal expression" (McCarl 1978).

Groom bandaging a racehorse's legs. Saratoga Racetrack, August 2014.

93

In speaking about the role of conversational genres within closed populations such as occupational groups, folklorist Roger Abrahams states: "Folklore develops as an esoteric statement of group solidarity and reflects the common aims and practices of the group and its shared ideals. The amount of apartness felt by the group and the amount of anxiety under which it exists is reflected in the amount of traditional expressions developed and the intensity of the life of such items" (Abrahams 2013). Speech acts such as proverbs, aphorisms, and superstitions require knowledge of the context of telling, as these speech forms are tied to the daily life, values, and functioning of a community of speakers. In his study of vernacular speech, Abrahams draws attention to the ways that everyday speech events indicate the worldview of the speaker. In his examination of the role language plays within occupation groups, he states, "There is a direct proportion between these esoteric factors (time, intensity, special activity, out-group exclusion) and the amount of traditional expression observable in the in-group." The development of code languages or special vocabularies makes this relationship especially clear. As Abrahams has observed, "Occupational groups involved in dangerous work or whose members spend a lot of time together on the job develop an abundance of jargon, most relating to their work activity" (Abrahams 2013, 49). Following

Abrahams's observation, personnel at the thoroughbred racetrack share a work environment that is dangerous, and both geographically and temporally bounded. Consequently, they share a highly specific and specialized set of vocabulary or argot, as well as a narrative style that relies on narrative folklore to comment on and make sense of their experiences.

The language at the racetrack falls within several categories of use. The first and most prevalent is the use of a specialized vocabulary that marks one as a member of the community of "racetrackers." This is a linguistic community that has historically existed apart from the wider general public, thereby developing its own ways of speaking. Those employed in the backstretch have a specific argot, a specialized vocabulary, that helps to maintain its exclusivity (Gumperz 1962). The ability to effectively use the language of racetrackers instantly marks one as being knowledgeable about this community and its concerns. The language used by the occupational groups involved in the thoroughbred racetrack has been compiled by lexicographers and dialect scholars. One such scholar, David Maurer, published the study "The Argot of the Racetrack" through the American Dialect Society in 1951 (Maurer 1951). This monograph was soon followed by Cummings's "The Language of Horse Racing" in 1955 (Cummings 1955). These two dialect studies serve as lexicons of the vocabulary

and unique expressions found within the backstretch.[2]

Reflecting the social interaction within the speech event, the communicative language is determined by the context of the situation (Silverstein 1998). As with similar in-group/out-group communication, there is an automatic switch in vocabulary used, a moment of "code-switching," in recognition that the individuals involved in the conversation do not share the same linguistic community. This is illustrated by the following comment from former jockey and trainer Ray Sibille, talking about apprentice jockeys: "I would have said the 'bug boy' but I thought you wouldn't know what I was talking about, but you do."[3]

In the conversational context, the term *bug boy*, referring to an apprentice jockey, is a term shared by the speech community of racetrackers but not by the spectators and consumers of horse racing. In this instance, Sibille adjusts his speech as he perceives that he and I do not share the same linguistic or occupational community.

The speech of racetrackers relies on a lexicon centered around the horse, its attributes, and its activities. Following Kenneth Burke's "occupational rhetorics"—vocabularies in which the world is described in terms relevant to the occupation at hand (Burke 1969)—the world of the racetracker reflects the nuanced reality of daily horsemanship. In an environment predicated on the movement of horses, there is a plethora of terms that refer to specific ways of moving. A horse who is "breezing" is running in a sort of training race with several horses beside him to get the feel of running with others. A horse being "schooled" is being taught the various elements it will encounter during a race; therefore, schooling can refer to a horse's practice of entering and exiting the starting gates, or being "ponied" around the track through being led by another horse and rider. A groom "rubs" a horse, an accurate descriptor for the brushing and currying that the horse is subjected to daily. A hotwalker who is leading a horse to cool it down after exercising is said to be "walking the hots."

Other lexical terms refer to the horse and rider in the situation of a race. A horse who is running well and then suddenly falters is said to "spit the bit," with "bit" referring to the short piece of metal that goes behind a horse's teeth as part of the bridle. A "cheater" is a horse who doesn't give 100 percent (Stevens 2002). A horse who is "on the rail" is running in the preferred position of the inside rail of the track, where the distance is the shortest. A rider trying to control his horse's position within a race and cause another horse to move wide or hang back is said to "float a horse out" (Stevens 2002).

The specialized language found within the backstretch is also used to describe the

physical nature of the environment. A groom calling to another groom asks, "where are you barning?," meaning "in whose barn are you working?" A "shed" refers to the barn or stable which are rented by the trainer to house their horses and to carry out their training activities. The shed row is that area in front of the rectangular, one-story barn structure covered with an overhanging roof, which is used to endlessly walk horses.

Language can indicate status within a community. The assignation of racetracker, to indicate the individual who has dedicated his or her working life to the backstretch and the thoroughbred horse industry, has a nuanced meaning. The term is not necessarily consistent with the idea of a horseman, as a horseman is an individual who is held in high regard for his years of service, knowledge of horses, and a certain concomitant financial success—an assignation that holds a higher prestige than the moniker of racetracker. At the lowest end of the spectrum, an unscrupulous trainer who may cause injury to his animals through his training practices can be referred to as a "butcher."

A "claimer" is a horse with inferior status, indicating that it is a horse that runs consistently in claiming races, in which the horse's owner has agreed to relinquish his ownership of the horse if it were to win the race.[4] A "bug boy" is the slightly pejorative term for an inexperienced rider. A bug boy is allowed to carry fewer pounds than is allowed in a standard allowance race and his or her status as an apprentice jockey is indicated by an asterisk in the racing program, giving rise to the term of bug boy to indicate the apprentice allowance that allows the apprentice to carry less weight. Once he "loses his bug," after forty races or one year, he is considered a full-fledged jockey. "Bug" can also refer specifically to the five-pound weight allowance that can be claimed by the apprentice jockey. A horse or a jockey who gains status from winning his first race is said to "break a maiden" (*Dictionary of American Slang* n.d.), and a race for horses who have never before entered into a race is said to be a "maiden race."[5]

In the backstretch, nicknames abound. Personal and family identities take second place to one's job position, employer, or ethnic group. Surnames are virtually unknown, as individuals are known by their first names and for whom they work. To locate someone in the backstretch, one must know who that person works for and in which barn, or location, they can be found during the day. Nicknames can refer to a person's physical attributes, such as "Red" for a red-headed groom or "Chicaleen" for a groom who is short and round-faced. "Cowboy" comes from Michoacan, a state in Mexico known for its horses and cattle. Alan Jerkens, a Hall of Fame trainer who is well

liked and well respected, is known universally by the honorific "the Chief."

Besides the specialized language used in conversation, the folklore of the racetrack includes a wealth of proverbial expressions. Roger Abrahams draws attention to the mitigating nature of proverbs—their help curbing anxiety through suggesting a course of action for the future. In stressful situations, and in arenas where there is uncertainty, a proverb can ease fears and help people believe they have control over the outcome of events (Abrahams 2013). This is indicated in the speech of the racetrack environment. Proverbial expressions such as "chickens today, feathers tomorrow" point to the mercurial nature of success within racing. Other expressions such as "riders don't make horses, horses make riders" or "good horses make good trainers" help explain a horse's inabilities to do well, or a trainer's or jockey's inabilities to succeed financially or on the racetrack, even after hard work and effort. It is commonly believed that success within racing is determined most by the athletic qualities of the horses in a race. The more colorful "you can't make chicken salad with chicken shit" brings this point into sharper focus.

Speech events at the racetrack also draw attention to the inequalities and subtleties of opportunities existing within the network that is the racing community. Pointing to the hardships that many consistently endure are proverbial expressions such as "they'll promise you the moon but they won't give you a star," meaning that sometimes those who expect to earn bonuses in a trickle-down fashion after a horse has won a race find that their remuneration has been forgotten. Other cautionary expressions include "the closer you stay to the horses, the less money you're going to make," drawing attention to the owner's position as the main beneficiary of any horse race with all others (jockey, trainer, groom, etc.), receiving fewer of the spoils depending upon their position regarding the care of the horse. Joking about the effort of keeping one's weight down to the acceptable level, former jockey, Bill Boland said, "The jockey is probably the fittest athlete in the world. For one reason. He stays fit twelve months out of a year. And if he eats he starves[6] and if he don't eat, he starves."[7]

The speech community found within the racetrack is one in which narrative acumen is appreciated and narratives abound. McCarl points out that the "occupational personal experience story" is the basis for oral interaction within the occupational group. He speaks of narrative clustering, whereby stories can supply an "internal ordering of expressive behavior" that, when analyzed, can draw attention to the most important concerns of the occupational group (McCarl 1978).

As I queried backstretch workers for examples of their working lives, their recognition of key individuals through personal experience narratives was part of the canon of inside knowledge. While the National Racing Museum and Hall of Fame annually honors those who are successful within the economics of racing with a public celebration, those within the backstretch quietly recognize their own heroes through narratives and a shared oral history. The names of specific trainers such as Alan Jerkens, "the Chief," are routinely offered up as examples to be followed. Legendary horses and legendary trainers are remembered long after their tenures have passed.

Accidents are also remembered, and their unfolding persists. The backstretch and its racetrack community abound with stories of individual success and horrific accidents. Narratives provide insight into the omnipresent elements of risk as well as the worldview of the racetracker—a worldview that values perseverance amidst physical hardship.

Trainer Forrest Kaelin began riding as a boy of barely sixteen years, dropping out of school to ride thoroughbreds. When asked about his career as a jockey, he recounted this story to illustrate the attitude of persevering within a dangerous profession:

The man that brought me out was a man called Phil Huber. But I rode for Calumet Farm. I rode for a lot of different people. I was the leading rider one year until I got wiped out and I was noted for dead that day. I laid up for six, eight months. I laid up and then I started riding again. Then I had another spill and was laid up again. Most of it was in the morning getting on bad horses. Crazy horses. If they had hair on them I thought I could ride them. That was tough. No I never got hurt bad in a race. Always in the mornings getting on horses I shouldn't be getting on.[8]

Tom Luther's previously recounted narrative about a jockey presumed to be dead is another example of the hardships experienced in the years before the formation of the Jockeys' Guild.

Bruce Jackson, in *The Story Is True: The Art and Meaning of Telling Stories*, states, "The facts of the past are of far less importance in our stories than the construction of the past in the present" (B. Jackson 2007). When I interviewed retired jockey Tom Luther in 1995, he was eighty-seven years old. Born in 1908, his tenure as a jockey had spanned the early part of the twentieth century. He had been active in the early 1940s with early attempts at the formation of a jockeys' union to help jockeys achieve a modicum of support and assistance in the event of catastrophic injury. As a well-known raconteur, many of his stories tell of

the dangerous nature of riding, as well as the hardships of the nomadic lifestyle demanded of racetrackers. These well-rehearsed narratives, as they were told to me, also provided a rationale and an explanation for his attempts at labor organizing.

Tom Luther's narratives, told for my benefit in 1995, were informational about the lifestyle he had maintained for several years. Within his community of racetrackers, the important role that Luther had played in the formation of the Jockeys' Guild was well known. Similarly, his stories of extreme accidents and the mistreatment of jockeys and their injuries were part of the canon of stories known to jockeys, exercise riders, and others involved in the care of racehorses. To the outsider such as myself, an affirmation such as "It's a true story, and I was there" is Luther's assertion of personal ownership for the positive change that has taken place because of the organization of the Jockeys' Guild and similar organizations. It is also recognition that the general public, represented by myself, has little understanding of conditions prior to 1940 that could be so horrific, and the life of a jockey so little valued.

Storytelling within the backstretch reflects the occupational pride of those involved in horse racing. Stories abound of famous racehorses and the unique bonds between humans and animals. Trainers routinely talk of memorable horses and the success they accorded to the trainer. These stories of famed racehorses are the types of stories that comprise much of the popular horse-racing literature, as sports writers valorize and write about well-performing horses. A more private trove of narratives about horses speak of horses for which the human/animal bond is particularly strong. These narratives may be about racehorses but they also include stories of working animals: non-racing horses or "ponies" who served within the racetrack environment.

Those who work on a daily basis with horses form strong bonds with their animals, who they see as collaborators in work. Those horses which are most beloved are memorialized in death by their owners/trainers, sometimes through the creation of personal items made from horsehair. Trainers may make a fly switch from the tail hairs of a beloved horse, using it as a personal aid in shooing flies away, in keeping with the horse's own use of his tail. Horsehair bracelets can also be braided and worn as a memento of a specific horse. These items of material culture can serve as a locus of conversation, providing opportunities to remember and reflect on one's personal bond with a horse.

Within the backstretch, workers rely upon and tell stories of accidents, unfortunate events, and heroic deeds as a guide to backstretch life and safety. The situation of telling takes place after one's work is completed, as

the compact nature of the workday precludes the leisure that storytelling desires. Narratives are told in conversation after the work is concluded: after the training track has closed for the morning, or later in the day after the afternoon's work has been completed. The tales are told to each other and for each other.

Similar to the tales told by emergency workers, as chronicled by Timothy Tangherini (1998), racetrackers use stories to exchange information, to comment on their working lives, and to impose order on what is a highly mutable living and working situation.

Fasig Tipton Horse Auction, Saratoga Springs, 2012. One of the highlights of the Saratoga racing meet is the August yearling sale run by Fasig Tipton. A social event for those involved with racing, the two-day yearling sale attracts high-bidding horse owners from as far away as Saudi Arabia.

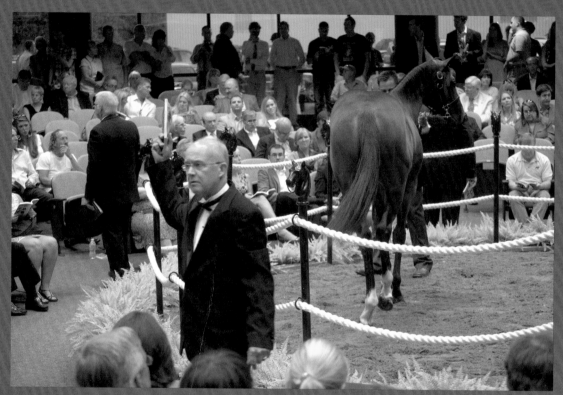

Fasig Tipton Horse Auction, Saratoga Springs, 2012.

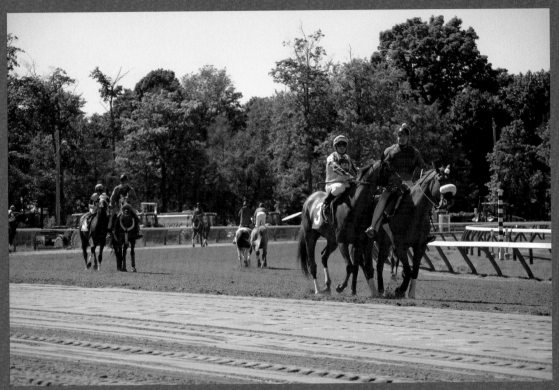

The "parade" of horses to the post, Saratoga Racetrack, 2012. Each mounted racehorse is "ponied" to the starting gate. A pony person is a contractual rider hired by a trainer to serve as a horse's escort to the starting gate during the afternoon's racing. In many cases, pony people spend their mornings as exercise riders.

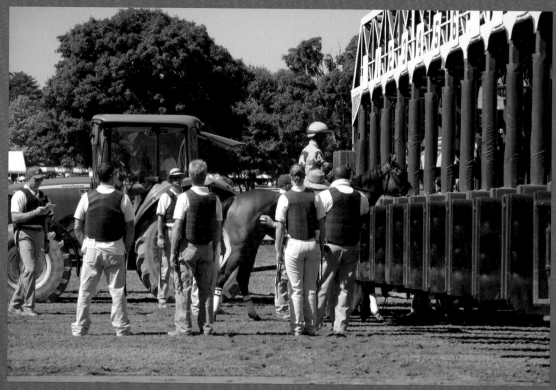

Loading horses into starting gate, Saratoga Racetrack, 2012. After being ponied to the starting gate, each horse is place in one of the chutes. Starting gate attendants, pictured here, help place horses in position.

Exercise rider Lorna Chavez, Saratoga Racetrack, 2012. Sporting her signature pink vest and riding helmet, Lorna Chavez is an experienced exercise rider who can be seen at Saratoga Racetrack and Gulfstream Racetrack in Florida. Originally from Great Britain, Lorna is a career rider.

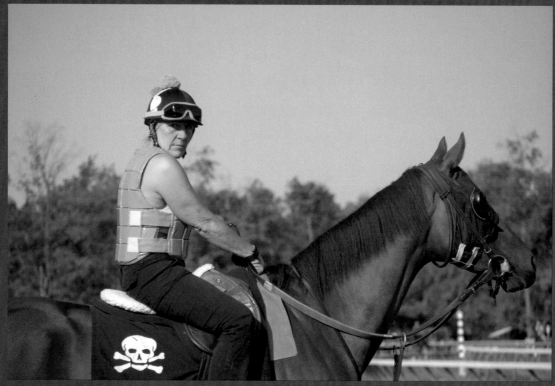

Exercise rider Lorna Chavez on a horse being trained by Edward Miller, Saratoga Racetrack, 2012. Decorated saddle towels, such as this one sporting the Jolly Roger, identify the stables to which a horse belongs.

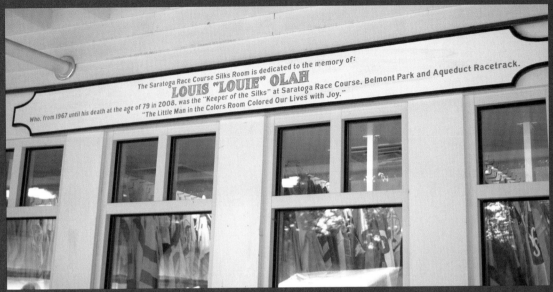

Silk Room, Saratoga Springs Racetrack, dedicated to Louis Olah. Known as the "Keeper of the Silks," Olah was an important part of New York racing for more than forty-one years. Originally a jockey, he began in the silk room in 1967 and remained there until his death in 2008. A jockey's silks, worn during a race, indicate ownership of the horse. Each color and design combination is registered with the New York Jockey Club and each is unique. Louis Olah was the undisputed master of the silk room, knowing many of the silks by memory.

Exercise riders during a morning workout Saratoga Racetrack, 2012.

Horse being loaded into a horse van at the close of the Saratoga Race Meet, Saratoga Springs, NY, 2012. As soon as the racing season ends at Saratoga, most horses are shipped to another location, either to their home stable or to another racing venue.

Signpost identifying Todd Pletcher Riding Stables, Saratoga Springs, NY, 2012. Trainers at Saratoga typically decorate their stable areas with floral plantings, lawn furniture, and signage that identify their rented stables as their own for the duration of the Saratoga Race Meet.

Decorative floral planters demarcate a stable area. A hot-walker walks a racehorse at close of the morning training period.

Lawn furniture and decorative floral planters provide a backyard feel to the stables. Furniture placed within stable areas provides meeting space for trainers and owners.

Stable decorations, such as signage and stall gates, include logos that proclaim the trainers' stables. These logos also appear on saddle towels worn by horses.

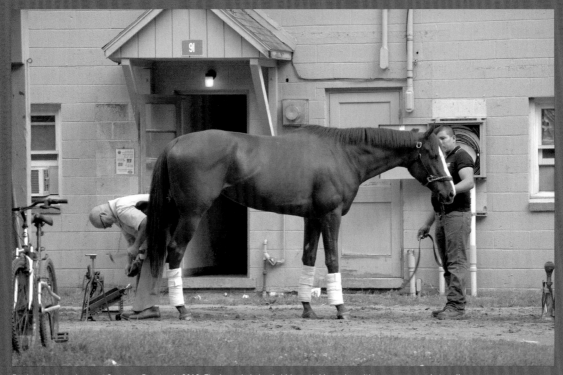

Farrier shoeing a horse at Saratoga Racetrack, 2012. The horse is being held by a stable worker, either a groom or a hot-walker.

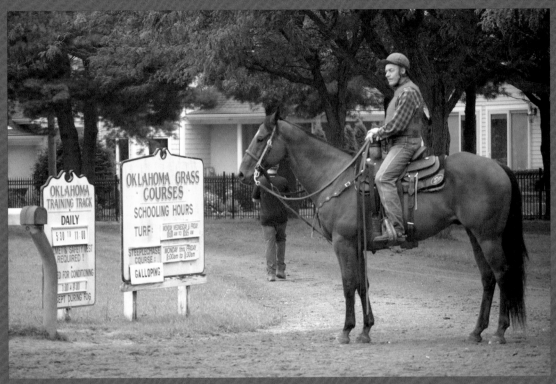

Outrider at the Saratoga Racetrack, 2012. Outriders can generally be recognized by their red vests and hats. This outrider is at the Oklahoma Training Facility at Saratoga. Rules for training are prominently posted.

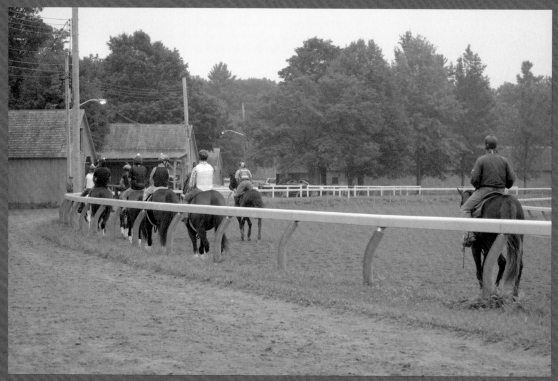

Exercise riders in a "set," Saratoga Racetrack, 2012. Riders often exit a stable at the same moment, working together to provide a safe environment for riding. These riders of trainer Christophe Clement often receive their riding instructions together "at the rail" before embarking into the training track.

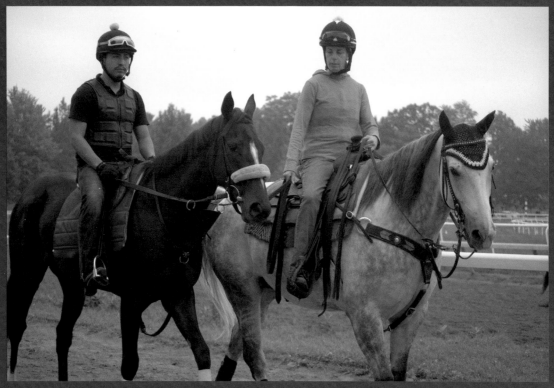

Sarah Camele Arnold ponying a horse for trainer George "Rusty" Arnold, Saratoga Racetrack, 2012. Arnold began at the thoroughbred track as a groom, quickly moving into the position of exercise rider. Today she is an active part of Rusty Arnold's training operation.

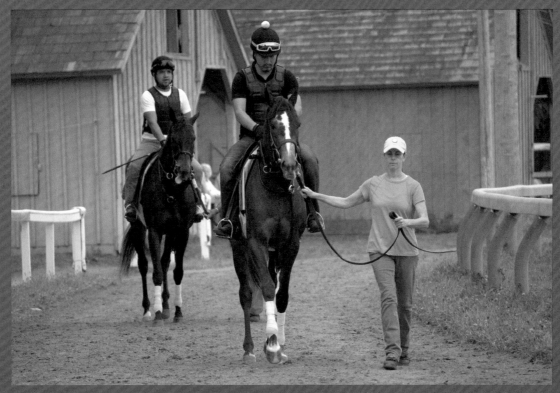

Sarah Arnold leading a horse and rider during the morning workout period, Saratoga Racetrack, 2012.

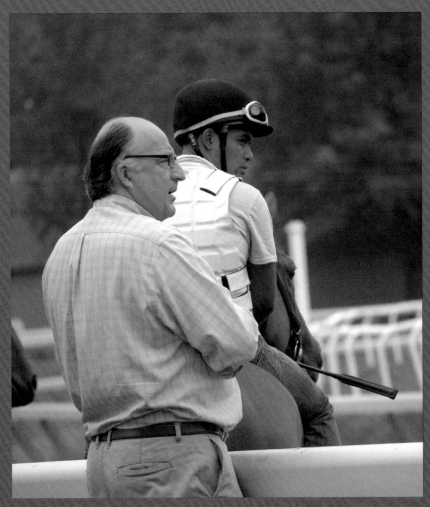

Trainer Christophe Clement observing his horses during training, Saratoga Racetrack, 2012.

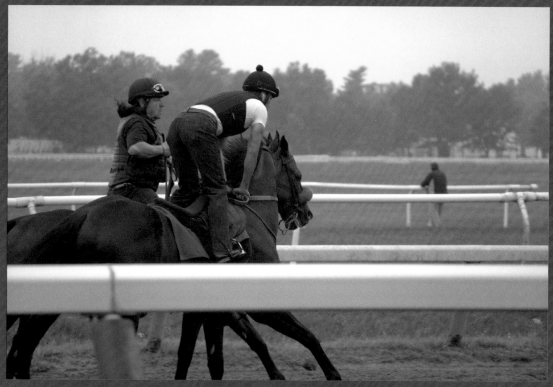

Pony person Juan "Bon bon" Galbez, ponying a horse and rider during the morning exercise period. Ponying during morning workouts is an important part of preparing a horse to run in a group of horses during a race.

Trainer Christopher Clement speaking to a jockey and his agent, Saratoga Racetrack, 2012.

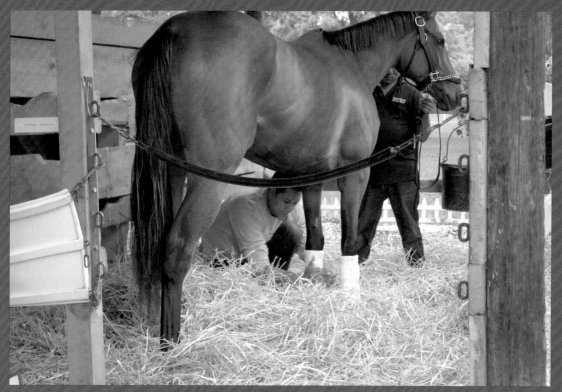

Groom bandaging a racehorse's legs. Saratoga Racetrack, August 2014.

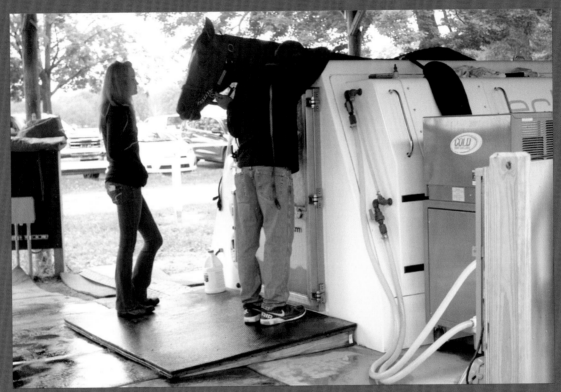

Racehorse in a therapeutic whirlpool bath. Racehorses receive newer therapies, such as whirlpool therapy, deep tissue massage, and acupuncture.

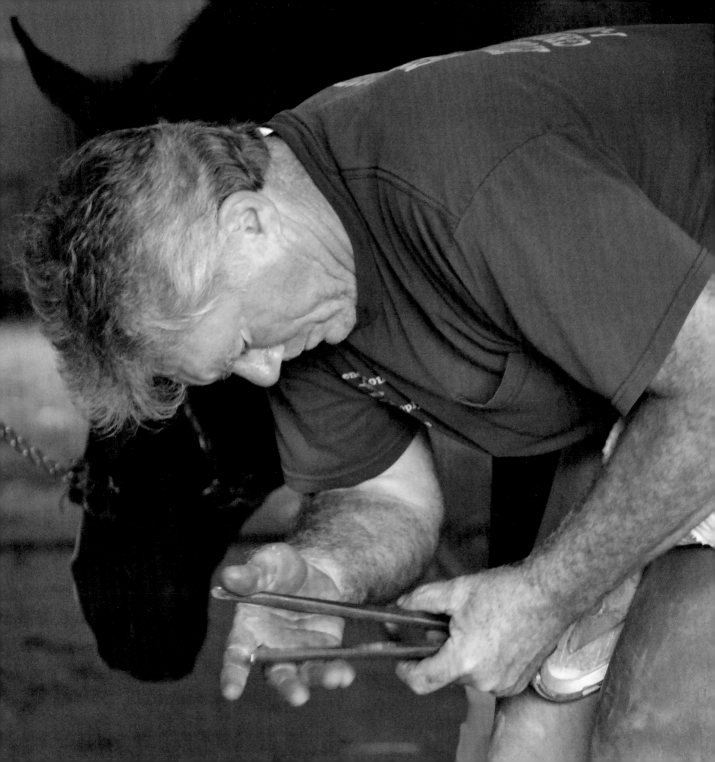

Chapter 8

Labor Lore

A man stood at the Heavenly Gate
His face was scarred and old.
He stood before the Man of Fate
For admittance to the fold.
"What have you done," Saint Peter asked,
"To gain admittance here?"
"I have been a racetracker, Sir,
For many and many a year."
The Pearly Gates swung open wide
As Saint Peter pressed the bell.
"Come in," he said, "and choose your harp,
You've had your share of Hell."
—RECITED BY HELEN LUTHER, 1995

A piece of folk poetry, this poem has been widely used to describe various occupations, including soldiers, teachers, social workers, wrestlers, dog breeders, and even fund-raisers. However, as adapted and penned by Helen Luther, wife of the famed jockey Tommy Luther, the poem offers a glimpse into attitudes toward the daily uncertainties of racetrack life. While racetrackers speak of the inclusive nature of the racetrack world—its camaraderie and the ability to find a niche within a group of like-minded individuals—the world of work in the backstretch can be unforgiving and precarious.

Farrier Tim Shortell, Belmont Racetrack, New York City, 2013.

The person working in the backstretch is subject to working long hours without regard to weather. The daily regimen begins as early as 4:30 and, even though trainers are subject to scrutiny by states' Departments of Labor, actual hours worked frequently extend past the legal forty-hour mark. It is a dangerous working environment, as those working with horses can be stepped on, kicked, thrown out of the saddle, and bit. If the horse one is rubbing or grooming is transferred to a distant racetrack, the groom assigned to its care travels with the horse in the horse van, sharing its journey and making sure that it handles the trip. As horses arrive at the racetrack for the beginning of a race meet, unloaded from jitney vans not only are horses but also the few possessions of a racetrack worker: his mattress, clothing, and a few articles to set up a new living situation for the duration of the racing meet. When asked what makes a good rider, exercise rider Lorna Chavez spoke about the love of horses:

I think it's the love of it. To really love the horses . . . I mean, if you don't enjoy it, you shouldn't do it. And if you're in just a rush to get as many as you can. You've got to have a feeling for a horse. You really do have to have a feeling. I mean, I love them. I mean I don't care if they're $5,000 claimers or stakes horses. To me they all get judged up the same. But It's just the

love of it. . . . I think it's just the love of the horse that makes someone a kind rider. You've got to be kind. You've got to love them. And if they put money in your pocket you've got to love them. They make you wealthy. Not quite! But it pays the bills. You can make a living.[1]

Wages vary widely within the backstretch environment. Trainers who are successful at racing and have a stable of well-achieving horses can earn in the millions of dollars. While successful jockeys are known for being the recipient of high purses, this wealth can be fleeting and quickly taken away if they are injured. On the other end of the spectrum, hot-walkers and grooms work up to fifty hours a week, earning the minimum wage or slightly more. A study by the New York State Labor Department in 2008, found numerous violations in the backstretch of the Saratoga Springs Racetrack, including underpayment of wages for hot-walkers and grooms, less than the prevailing minimum wage in 2008 of $7.15/hour (Greenhouse 2008).

I wish back here in the backside . . . the backstretch people . . . they need people to help. . . . The people from the backside need more help . . . support. Because these people work seven days a week. They don't really have too much life here. . . . But

back here you need a little more help. You have a lot of people. Poor people . . . they are not allowed to do anything. Just lay down and sleep and get up the next morning and go to work. . . . You make the rules for your accommodation. Not for them. You make the rules to help you out. Not help them out. . . . A lot of people, they make those guys work more than they are supposed to. . . . Everybody at the backside.[2] Some people, they work more than they are supposed to and they get paid the same. . . . Wherever you go it is the same thing. That is the people who work in this industry.[3]

Trainers and some exercise riders typically rent lodging for the eight weeks of racing season at Saratoga. Lower-paid workers such as grooms and hot-walkers are not able to afford the high rents of off-track housing and are therefore housed in single-sex dormitories found scattered among the horse stables. Cooking is prohibited in these lodging facilities for reasons of fire safety. This prohibition further exacerbates the impact of low wages, as all meals have to be eaten at one of the racing track's kitchens, from the roving food trucks that ply their trade in the backstretch, or off-site at fast food restaurants. Meager wages can be quickly diminished when having to purchase every meal.

I was in the Grandstand. Well, I run a horse every day, almost every day I never get a chance to go to the Grandstand to just enjoy the races. Never. So the other day I really want to get a popcorn. This is funny. OK. So I get a popcorn and a lemonade. Fresh squeezed lemonade. Wow! Beautiful! I say, "How much is it?" "$11.25." . . . "Really!" So for those guys to go to the Grandstand . . .

These people work to make the racing go. For them to go over there and buy something, that's half of their check. Do you know what I'm saying? Even to go to the kitchen here to buy something in the kitchen . . . [It's not cheap]. But they are not allowed to cook here. . . . You have to work seven days a week and rent someplace outside if you want to live decent.[4]

Although housing at Saratoga is temporary, that which is found at other tracks is often similarly basic, with no kitchen facilities and a shared bathroom that could be a short walk away. A shared dormitory room consists of a mattress lying on a concrete floor and few other amenities, only one step up from camping for the short time of the racing meet. A weekend of heavy rain provides a dreary backdrop to heavy physical labor.

However difficult living circumstances are in the dormitory, the dormitory is preferred

housing compared to the housing of those who live "in the shadows" of the track—due to extreme poverty or undocumented status. While not commonly acknowledged, stable hands frequently are found living inside tack rooms within the actual horse stables. Whether in Louisiana, Florida, or New York, undocumented (as well as documented and American) workers can be found living in single rooms at the end of the shedrows, sometimes with their families.

Track conditions vary throughout the United States. Some have no housing available within the environs of the backstretch, with workers having to find housing in any of the communities surrounding the location of the racetrack. Others provide modest housing with or without support services for those who work in the racetrack community. Many racetracks have a kitchen facility that provides meals to those working in the stable area and some of the larger facilities, such as the Saratoga and Belmont racetracks, provide laundry facilities and recreation in the form of soccer leagues and bus excursions. With the growing number of female track workers, efforts have been made to improve housing and provide for families on racetracks. Belmont racetrack includes a childcare facility, and many tracks now have organizations such as the Backstretch Employee Service Team (B.E.S.T.) to organize English as a Second Language classes, promote family

activities, assist with visa and immigration issues, and provide social welfare services to racing families. Other organizations assisting racetrack workers include those organized around the racetrack chaplaincy (Gordon 1995).

The industry is regulated by those at the top echelon of American economic life, in the form of the Jockey Club. Local jockey clubs existed in the United States from the mid-1800s and were designed as officiating bodies to control and set rules for horse racing at the local level. In 1894 an elite group of racehorse owners formed the Jockey Club in New York City, with the intention of controlling racing and racetracks along the Eastern Seaboard of the United States (Case 2001, 9). While their original formation was only to control racing in New York and Delaware, eventually their influence spread until they were the governing body for thoroughbred horse racing throughout the United States. The Jockey Club's Rules of Racing, adopted May 1, 1895, serve as the standard for racing in the United States (Jockey Club of New York 1895), and the august body of the nation's wealthiest elite became the standard bearer for regulation of the horse racing industry. In her examination of the formation of structures for thoroughbred horse racing in the United States, Carole Case outlines the history of wealth and power within the horse-racing industry. She describes the founding of the Jockey Club in this way:

On its own (and following the British model), the Jockey Club wrote, interpreted, and enforced the rules that became horse racing law in New York and Delaware. Their rules were also honored by other states. The Club assigned racing dates, issued licenses, and appointed judges. Henceforth, the Club alone dictated who could train, ride, and own horses. In return for this power, the Club promised to save the sport from gamblers and bookmakers, from the absence of a set of rules held in common, and from horses of questionable pedigree. (Case 2001, 19)

Two years after their formation, the Jockey Club took over the task of registering all North American thoroughbred racehorses in their central registry. Their absolute authority was eroded by the New York State Court of Appeals in 1952, who ruled that the licensing powers given to the Jockey Club by the legislature were unconstitutionally given to a social and exclusive group of sportsmen (Ferraro 1992). Even with regulations imposed by states' legislatures, the Jockey Club's control continues to hold sway over the setting of the racing schedule, the licensing of jockeys, trainers, and owners, and the enforcement of the rules of racing (Ferraro 1992). It keeps a registry of racing silks, which it requires owners to register. The Jockey Club monitors the safety and care of racehorses and keeps track of industry trends and issues and works in tandem with states' legislatures to control the sport of thoroughbred horse racing.

In their work, Ray and Grimes (1991) name the Jockey Club as the oldest and strongest horse-breed registry in the United States, with the most powerful and influential owners and breeders in the industry. Their membership is currently holding at approximately one hundred members, who are elected for life (Ray and Grimes 1993). Jockey Club members include multimillionaires, owners of racetracks and breeding farms, industrialists, oil men, and financiers. Since 1894 the Jockey Club has included members of racing's elite— those with surnames like Belmont, Mellon, Whitney, Clark, and Vanderbilt (Case 2001). In an industry where vast sums of money are wagered and change hands, those having a controlling interest in racing reap vast benefits at the expense of America's poorest workers.

Owners, and especially those who belong to such prestigious bodies as the Jockey Club, regulate and control the horse industry. Thoroughbred owners have a great amount of power over the working lives of the thousands of racetrack workers, including the health and work of jockeys and the regimen and training methods of trainers. Throughout the twentieth century, horse owners shaped the thoroughbred horse industry in profound ways

through their influence on legislation. To the extent that they affect and support the work of horse trainers, racehorse owners have also maintained the status quo in regard to job security and advancement within the racing environment.

In the eighteenth and nineteenth centuries, horse breeders and owners in the slave-owning South had a ready labor pool of enslaved labor to draw upon to serve as horse trainers and grooms. Stable boys and exercise riders who showed promise were trained from an early age to care for and ride the thoroughbred horses that were kept for the sporting pleasure of wealthy landowners. In a description of racetracks in 1850s New Orleans, reference is made to enslaved jockeys "wearing the colors of their owners" (Reinders 1964). Enslaved jockeys were sometimes allowed to keep a portion of prize money, providing a modicum of income that elevated these enslaved horsemen in the eyes of their community and could provide eventual freedom. Narratives of such success have been told of the enslaved jockey Cato, who was provided his freedom after winning a prestigious Kentucky match race[5] between a Virginia-bred horse, Wagner, and the Kentucky-bred Grey Eagle on September 30, 1839. Upon winning the race against Grey Eagle and his white jockey, Wagner's jockey Cato was granted his freedom by his owner as a reward for his victory (Drape 2006). Within the slaveholding South, enslaved trainers, grooms, and riders held particular regard within white and black community circles if they were considered to possess superior skills of horsemanship. Their work as horsemen was integral to the development of horse racing as a national pastime (McDaniels 2013).

This long-standing relationship of horse-owning elite controlling the fates of their workers continued nationwide in the post–Civil War era and into the twentieth century. Even for riders and jockeys who had not been part of the slave-owning South, control of wages and the fates of riders persisted well into the twentieth century. Until the 1980s apprentice riders entered into a contract, in a form of indentured servitude. The apprentice jockey was apprenticed to a trainer for a period of approximately four to five years, working until he or she achieves full-fledged jockey status through completing the terms of the contract and winning a prerequisite number of races. At that point an apprentice becomes a full-fledged jockey, able to work as an independent contractor. During their apprenticeship period, apprentice jockeys often serve as exercise riders, grooms, and all-around stable help for the trainer. Former jockey and trainer Tommy Luther explained:

> When I started out in 1925, you know, I went with a man—Stewart Polk. . . . And

Phil Chinn was the one that owned my contract because the man that first owned me (a five-year contract), he got stuck for money to get out of the hotel so he put me in hock for $1,500 to Colonel Phil Chinn.[6] So Phil Chinn had bought me, or had put up the $1,500, so he could get out of the hotel.

So now he got his $1,500 back together and he wanted to get me out of hock. He came back to Phil Chinn to get me out of hock and Phil Chinn wouldn't give me up. [By then he had learned to ride and he was more valuable—Helen Luther interjects] I had spent two years in learning how to ride. An exercise boy.

So Phil Chinn kept my contract but he had leased me out to Stewart Polk. Stewart Polk was a good man. He had developed a lot of good riders . . . four or five top riders and then it'd come to me. So now I got to riding good.[7]

As this narrative reveals, those who were under contract for riding to a specific stable could be traded for the settling of a debt, with little recourse for their own personal fates. "Owned" by the holder of the contract, the apprentice served a period of indentured servitude. His term can be transferred to another with no recourse. Young boys who showed promise as a jockey—either through knowledge of horsemanship or through their small stature—were often recruited by large horse-breeding stables. Former jockey Lou Hildebrandt writes of signing a five-year contract with Sanford Stud Farms in Amsterdam, New York, "without ever having sat a horse!" Signed at the age of eighteen because he weighed ninety pounds, Hildebrandt received $30 a month for an indenture that began in 1936. He writes, "The contract was an indenture stating the Sanford's were my masters" (Hildebrandt 2003). In the apprenticeship situation, the trainer controlled much of the apprentice jockey's life, providing food and housing as well as serving as the apprentice's employer. In addition to board, lodging, and medical care for five years, Hildebrandt was to "serve his employer and to keep his secrets,[8] and to obey the lawful directions and instructions of the employer or of his representative or trainer" (Hildebrandt 2003). Hildebrandt went on to race as a jockey until his retirement in 1947.

Retired jockey Ray Sibille was one of the last of the jockeys who started with a contract of indenture. He began racing in his hometown of Sunset, Louisiana, when he was just twelve years old. At sixteen he entered into a contract with trainer Butch Legers.

Back in that time, a jockey, he had to work for somebody. He had to have a contract

with somebody. You had to have a trainer who held your contract until you lost the apprentice. So that guy, you would work for him. . . . It was always a guy who had a lot of horses. Had a big stable and he had time. He could afford having a young kid that'd come around to get started. . . .

So, that was how I would start, you know. You'd start off working for somebody. And if he had a lot of horses, the more that you could get on the more things you'd learn. And when you started riding, you rode for him and if he had a horse in the race that you didn't ride, you can't ride the race. I was lucky enough to get started and get going good. And went on. Thank God.

We had a whole barn full of horses, and that is what you need as a young rider. The more you can get on, the better you're going to get. They don't have that anymore. Now a guy just comes here, he gallops for a couple of months and all of a sudden he's a jockey. Back then, man, you had to work in the barn and learn everything and really, really work hard. . . . And you had to have a contract, a contract holder. He was kind of like, he was your guardian and if he felt you wasn't ready to ride yet, he wouldn't let you ride. You had to be ready.[9]

One of ten apprentices or bug boys for Leger, Sibille recognizes that those under contract could fall victim to unfair practices:

Right after I lost the bug,[10] really the next year or two was when they stopped the contracts. They stopped the contracts. I believe it was a good thing in one way because if you got with the wrong guy he could work you to death and you had to do it. We worked hard, too, you know, but it paid off because when he felt I was ready, I rode them all. I rode them all and started really winning good.[11]

Jockeys can also achieve the title of "horseman." Historically a field that capitalized on the efforts of boys, a jockey now not only has to be a proficient rider but also has to be able to maintain a weight of 108 to 118 pounds. The effort to maintain this weight over time has compromised individual health and has caused many individuals to move into other occupations within the horse-racing industry when the toll of maintaining a low weight has been too difficult. Former jockey, now trainer Forrest Kaelin put it this way: "I used to ride, I rode for ten years. Ate my way out of the saddle! I had a good career. Won about eight hundred races riding. I was small and a friend of ours introduced me to a man who had a horse and he introduced me to

his trainer. . . . I was just getting ready to turn 16 so I dropped out of school."[12]

As is typical for apprentice riders, Bill Boland[13] began riding at the age of fourteen for Keane Ranch in Texas. When the yearling horses were shipped to New York State with trainer Max Hirsch[14] the following year, Boland followed the horses to New York and remained. When he arrived in 1948, there was no housing in Saratoga for those who worked in the backstretch; Boland remembers living in a tent in the stable area of the racetrack. He says of this time in his life:

I loved it. Sure, fifteen years old, living out. It was great! We had cots. You'd get up in the morning and you'd freeze to death. It was cold. It used to be real cold in the morning and then about 8:00 it would warm up. In fact I stayed up here one year. I was with Max Hirsch. I bought a couple of yearlings in the sale here. We stayed here three weeks in September to break them and some mornings there was ice in the buckets. It was cold. I loved every minute of it.[15]

Jockeys who no longer wish to risk injury on the racetrack, or who have become injured and are unable to ride any longer, frequently move into the position of horse trainer. Along with scores of others, jockeys Bill Boland, Ray Sibille, Forrest Kaelin, and Angel Cordero all made the transition from jockey to trainer. Cordero began his career in racing by working as a groom as a young person in Puerto Rico. His father and both of his grandfathers were horse trainers in Puerto Rico, and Angel learned to gallop under the tutelage of his father. He had this to say about his transition to trainer: "Well, I was riding for a long time and I couldn't ride anymore because of my accident. Being that I've been around horses for a long time. So that was my next step. Just stay around them. Work around them."[16] Boland described his job changes in this way: "I went backward. I was a jockey making good money. And then I quit and went to training and lost money. And now I'm coming here [as a placing judge] and making a living."[17]

Other former jockeys are happy with their work as trainers, allowing them to remain in the backstretch environment long after they have stopped riding. Ray Sibille is one such trainer. Born in Louisiana, he won his first race (his "maiden") on June 29, 1969, at the age of seventeen, and continued to ride for a career that spanned thirty-five years. Ray retired from riding in 2004, returned to his home, and began his new job as a trainer. Today he is training horses at the Evangeline Training Center, the site of his maiden race in 1969. He said:

I started riding here. This was a racetrack and I started here in '69. I left here in '73 and went to Chicago and stayed there for ten years. Then after that I went to California and stayed over there about twelve years. And then went back to Chicago.

Then . . . my hip was hurting me . . . and I found out that I needed a whole hip replacement so once that was that. I couldn't ride anymore after that. I was old enough. I was fifty-two. So it was time that I retired but I didn't want to. And I just fell into this training.[18]

Boland rode as a jockey for twenty-one years; when he stopped riding, he trained horses for nineteen years. In a 1994 interview, he had this to say about his time as a trainer: "I trained for eighteen, nineteen years. Yep. Worst mistake I ever made in my life . . ."[19]

While not as commonly known, some experienced jockeys also "retire" into work as exercise riders. This transition can provide a less taxing role, retaining one's connection with horses and riding but eschewing the highly stressful role of jockey. As with many other sports, young competitors are prized. Older jockeys may find that they increasingly have difficulty in obtaining mounts, and therefore search for avenues to stay connected to the world of racing without the high levels of risk.

With the loss of the system of the apprenticeship contract, today's aspiring jockeys can gain experience through working as exercise riders. They can also attend a training school that was founded in 2007 by Hall of Fame jockey Chris McCarron, as part of the Kentucky Community and Technical College system. This first-ever program to train jockeys follows a two-year curriculum and those completing the program earn an associate's degree (McGarr 2007). For riders, the progression from exercise rider to the public position of jockey is not necessarily a foregone conclusion. Exercise rider Lorna Chavez spoke of the difficulties of transitioning from exercise rider to jockey:

It's not [a simple progression from exercise rider to jockey] when I think about it. It doesn't happen that often. I mean . . . when you look around and see all these boys who want to be jockeys and ride. There's not that many trainers who give them their first-time opportunity . . . have them as their apprentice kind of thing and started them off, and stuff like that.

The only one I know who does things like that is the "Chief." Alan Jerkens,[20] he gives people a start and gets them going. But there's not that many that I can honestly say—I mean, there's not that many American jockeys. Most of them are from somewhere. . . .[21]

As previously described by Ray Sibille, once the system of riding under contract was outlawed in the 1980s, there was a breakdown in the training regimen for apprentice riders, and a loss of the idea of mentorship. As with other situations in which a young person finds him or herself suddenly within the public eye—as in an elite level of sport or within the entertainment industry—sudden fame can have a deleterious effect, says Sibille: "Nowadays they come and they're starting too young and all of a sudden they lose their bug and they're thrown into the deep water. And then some make it, some don't."[22]

Within thoroughbred horse racing, jockeys were perhaps the first to advocate for better pay and better working conditions. Jockeys met secretly in the 1930s to talk about raising money and creating a fund to assist injured or disabled jockeys and to help the families of those who were fatally injured. Jockeys such as Tommy Luther were blackballed because of their efforts ("Jockeys' Guild History" 2014). Their long-fought battle culminated as early as 1940 in the creation of the Jockey's Community Fund and Guild. The purpose was primarily to provide "a fund by contributions and dues which may be distributed as financial aid" and was specifically referenced as a "non-union" body (Farra 1998). Tom Luther described his reasons for working toward the formation of the Jockeys' Community Fund and Guild:

Why I started the Jockeys Community Fund because I came from California to Canada, where Canada there was very poor racing. We didn't have any ambulance at the racetrack. We didn't have any doctor. And a buddy of mine that rode in the same race that I'd won, had a fall. And he laid on the table like this where'd we put our saddles from the first race to four o'clock in the afternoon. Well somebody was going to town and put him in his car and took him to the hospital.

He stayed in the hospital and I had to leave because we were obligated to go to Chicago to race. They only race seven days a week in Canada [laughs]. And so I went to Chicago I heard from this lady, Mrs. Harrison, that used to take care of the riders. He had passed away with a broken back and three vertebraes, from the fall. . . .

When they got me for starting this Community Fund. It was called the Community Fund but it was the Jockey's Guild. So that is what they jumped on me. They ruled me off for starting that. I couldn't get on the racetrack at Santa Anita.

I put pressure so that they had to give me license to gallop horses. Now after I rode races for nine or ten years before and they took my license away from me. And her [wife, Helen Luther] and I was out

there, no job, no nothing. And that was a hardship on us.

Helen: And then the thing that really got him when they gave him permission to come on the racetrack in the morning to gallop horses in the morning so he could make a living they gave him an exercise boy's license.

Tommy: That was a disgrace. An insult to intelligence.[23]

Luther's banishment from the Santa Anita Racetrack for the 1939–40 race meet served as a deterrent to other riders joining the cause, as many jockeys were fearful that they would also be denied mounts to ride. However, jockeys in other areas of the country began similar efforts and the Jockeys Community Fund and Guild was successfully formed in 1940 (Farra 1998).

Today, jockeys can ride for as many as ten different trainers in the course of a race day. In Maryland, the Maryland Jockey Injury Compensation Fund considers jockeys to be employees who are entitled to worker's compensation. Maryland-based owners and trainers are charged accordingly. In an environment where injuries are common, only four states—California, New Jersey, New York, and Maryland—mandate worker's compensation insurance for jockeys and exercise riders (Jones 2006). Most recently, racetracks are exploring ways that they can offer worker's compensation at group rates for the trainers who race within their facilities (Freer 2013).

While the formation of the Jockeys' Guild created a safety net for financial assistance for jockeys who may be injured on the job, the founding of the guild has not spawned a similar organization for exercise riders. Exercise riders continue to work as contractual workers with little recourse if they are injured in the course of their work. Former jockey Bill Boland spoke of the Jockeys' Guild's important role as a labor organization:

At least [as a jockey] you have some bargaining power. Jocks stick together pretty good. You want something not unreasonable, but if they want something done they get it done. Before they used to tell you, "Pack your tack." Before they could tell you they don't want you riding here and you had no recourse. Just packed you tack and left. . . . But now they can't do that.

And the Jocks' Guild had something to do with that, plus the law's changed too. There was no appeals, no courts, you know. They ruled and you went by it but nowadays you suspend a jockey . . . He gets ten days for careless riding, he can go get, he gets an appeal and then he has to wait for a hearing. In the meantime he can ride where before he couldn't. They

could say, "We don't want you here, go," and you left.[24]

Women have become more and more accepted at the racetrack—as hot-walkers, grooms, and riders. However, female jockeys are still rare, as are female trainers. These positions of authority form the public face of horse racing and remain largely the domain of men. While some women have broken through that proverbial glass ceiling, many aspiring female trainers never succeed. Bonnie Bernis, who was working as a groom when I met her, is the daughter of a Louisiana trainer and was hoping to one day move into that role. As a teen, she had begun working for her father and had traveled to Saratoga in 1996 to work as a groom for a Kentucky-based trainer. She said: "I got a training permit over a year ago but it's so tough for women. So tough. I've talked to a couple of people and they say, yes, yes I'd love to have you train a couple, but they never say when. Come on, give me a break."[25]

Lorna Chavez, in describing the job roles within the backstretch, commented: "Then you progress to a groom . . . And then you can go to an assistant trainer where you're overseeing everything then. And then you marry one [laughs]. Maybe this isn't right [laughs]. Then you're the trainer's wife and that's as far as you go."[26] That Chavez would mention marriage as part of the progression from rider to a higher position is indicative of the remaining barriers for equal participation by women. The marriage between a rider or assistant trainer to a trainer is quite common, with many couples sharing the job of trainer or identifying their partnership as "trainer and assistant trainer." In other cases, especially in small operations, a husband might be the designated "trainer" for horses "owned" by his wife. In the role of exercise rider, however, women are particularly accepted. A.J. Credeur, general manager of the Evangeline Training Center, spoke of the abundance of women within thoroughbred racing in Louisiana:

Our Cajun women probably make the best horsemen. We have quite a few women that work here, quite a few. Just like your gallop girls. Gallop girls, they make good, good horsemen. A nervous horse, you've got a horse that's a little antsy, a little nervous, or whatever. You put a girl on him and, I'll be darned, she'll have him settled down and he'll be paying attention because I guess they don't feel the 'tensity of a man on them that just wants control, or whatever. You put a girl on him and all of a sudden they just, they mellow out. It works . . . because horses relax for them.[27]

Chavez is outspoken on the subject of women and the care of racehorses. Trained in

England as a steeplechase rider, she came to the United States in 1996 to work on a thoroughbred horse farm. While in the United States, she began to race on the flat track, and now makes her living as an exercise rider in the morning for several different trainers, and as a "pony person" during the races. She said:

They are very male chauvinistic at home [England]. Here, I mean, you see a lot of exercise riders that are girls. A lot of exercise riders. They say that girls are a little bit kinder on horses. And the horses do run. I found when I was riding steeplechase and then on the flats at home. Horses ran for me. I mean, I don't know why but they did run for me. It happens . . . like Rosie now.[28] Horses run for her. Julie Krone—horses run for her. You know. They do run for girls. . . .

I was the first professional girl ever to have a license at home [in England] on the flat and steeplechase. It wasn't heard of. The girls who rode at home were amateurs and they just rode for their family. But over here they're like professional and they all do really well. There are quite a few girls riding races now. But there are a lot of girls in the morning that like horses. A lot of girls . . . Yeah, [the trainers] like girls on horses in the morning because they have patience and they're quieter on

them. They are, generally, just quieter on horses.[29]

Horse racing has only been accepting of women as true participants within the last fifty years, and then in only certain sectors of the sport. While women had been racing prior to World War II on local racetracks, women were not "granted" the right to obtain a jockey's license until 1969. A handful of trailblazing women, including Diane Crump, Barbara Jo Rubin, and Kathy Kusner (Davidson 1999) attempted to enter the male bastion of the racing oval, but women were deemed to be inadequate for the role: their bodies were the "wrong shape" (Butler 2012) or their reflexes were not fast enough. However, already recognized for their abilities as "gallopers," women increasingly began to seek status as jockeys. Diane Crump was the first woman to ride as a jockey at Hialeah Park in Miami on February 7, 1979 (Davidson 1999). Bill Boland, a former jockey turned placing judge, attributes the entry of women into the racing industry to the 1960s:

I know the first girl that was supposed to ride, she was at Tropical Park and I was vice-president of the Jock's Guild at the time and the jocks refused to ride against her. So they took her off that day and put her on a horse the next day, but all the jocks got fined and I had to go down for a

hearing. They were going to suspend them and fine them but they would up fining them $300 or $400 a piece and they let it go.

But that was the beginning of the girls.[30]

Even then, resentment from male jockeys was apparent and jockeys boycotted races that included female riders. The women were verbally harassed and attempts were made to intimidate them or to interfere with their riding (Davidson 1999).

While female jockeys were the target of obvious gender discrimination, discriminatory attitudes were present for other backstretch roles. Licensed trainer Lee Erb, who worked in conjunction with her husband Dave[31] and shared equally in training duties, remarked that owners always took her more seriously when her husband was present. Female trainers with their own stables continue to be rare, although successful trainers such as Linda Rice consistently excel within America's premier racetracks.[32]

Historically, sport has strong relationships with masculinity. "Sport is a social world that remains dominated by strong configurations of traditional masculinity, although this is changing and many women are challenging these attachments through their participation in a wide range of sports" (Woodward 2011). Like boxing, horse racing historically engaged the imagination of men, in the structures of work, and in the networks of "organizers, spectators, and reporters" (Woodward 2011). Throughout history, the barn and stable were the domain of men and boys. The horse race was an enactment of male hegemony and, even in its vocabulary, horse racing is evocative of the subordination of the female and female sexuality.[33] Women may have accompanied their husbands and brothers to the racetrack but they were there as onlookers, contributing only to the social situation of the race meet. A Louisiana-based trainer spoke of the gender roles predominant in mid-twentieth-century Louisiana:

The man was such a domineering, in the '50s and '60s, you know. "This is it, that's it. You stay home and cook." You know how it is. It's different now. My mother was just used to [my father] being in the business and he had a little house behind the house they had where he had a lot of jockeys, black boys, that lived in there. And she had no choice. They were going to ride. . . . She had no choice, but times have changed, you know.[34]

Sociologist Edward Rosecrance states: "Those who make up the backstretch traditionally have been accorded low prestige and

have been relegated to the bottom of the hierarchical order. In colonial times, the backstretch was made up of slaves and indentured servants who lived in quarters near the horse stalls. They were controlled by the overseer who doubled as a horse trainer" (Rosecrance 1985). In the antebellum slaveholding South, the stable areas of racetracks were populated by African American men who served as its workers. Generally, in the nineteenth and early twentieth centuries, African American workers dominated the backstretch environment as hot-walkers, grooms, exercise riders, and jockeys. In her study of African Americans in the resorts at Saratoga Springs, Myra Armstead notes that the racetrack at Saratoga Springs provided African Americans summer employment as jockeys, stable hands, and grooms. She notes that one historian found that most stable hands at the Saratoga track were black (Armstead 1999).

In the twentieth century, the role of African American racetrack workers generally declined, replaced more and more by those from a white working-class background, especially in the northern states. In the late nineteenth century, black hotel workers in Saratoga Springs were increasingly replaced by immigrant European labor in what was an increasingly segregated labor market. This was mirrored by increasing racial discrimination at the racetrack, as black jockeys increasingly were subjected to fierce and sometimes violent competition from Irish jockeys. Armstead notes that, by the period's end, black racetrack workers at Saratoga were relegated solely to the position of groom (Armstead 1999). Mary Jean Wall, in a study of horse racing in Kentucky, writes about this turn-of-the-twentieth-century change in the demographics of horse racing. She states, "In 1900 the *New York Times* had reported that black riders disappeared when a quietly formed combination [of whites] formed in New York to shut them out." Responding to the increasing violence against African Americans throughout the country, and the prevalence of lynching, which reached its highest numbers during the 1890s, black horse trainers also began to disappear from their high-profile positions. Those who might once have been trainers now were more likely to remain as grooms. Aspiring jockeys were more likely to remain exercise riders for the morning workouts. Thoroughbred racing in the twentieth century increasingly became a sport for whites, until changes began to occur once again in the 1960s (Wall 2010).

In an oral history of African Americans in the Kentucky horse industry, former jockeys and trainers pointed to increased revenues in racing as being an impediment for future participation by blacks at the highest levels: "I don't see too much of future for Black people. Unless you get lucky enough to get a Derby

horse, I don't think so. It is a rough industry. They were making as much money. As soon as the money came, they pushed them [black trainers] out one by one so that you can count [the trainers] on one hand. Very few of them have good horses."[35]

Cleveland Johnson, a trainer based at Aqueduct racetrack in New York, echoes these sentiments. Born into a Cajun family in Rayne, Louisiana, Cleveland grew up riding in match races, making five dollars a week for his work around horses. After graduating from high school, he made his way to Boston, where he began working for trainer John "Butch" Lenzini in 1970. Elevated to the job of assistant trainer by Lenzini, Cleveland Johnson talks about his first encounters at Belmont racetrack in 1982:

After high school in 1970. I left home after I graduated in 1970 and I landed in Boston. That's when I met Butch Lenzini in Boston. I started out as a groom. Then 1978, I think, I became an assistant trainer. 1978.

So we stayed in Maryland and came up here in 1982. So I got here and it was amazing. There was one black trainer at the time—a guy by the name of Chester Ross. He's died . . .

I was the only African American assistant trainer at the time. Being black, and I was wondering why I was the only one being black. It was amazing. You know. I was shocked.[36]

Cleveland concurs that the role of money and increased purses in racing changed the perception of the sport. With the ability to earn higher purses, more and more people began to be attracted to horse racing, pushing African Americans out of positions that were potentially positioned for higher earnings.

The stories of African American jockeys are just now beginning to be told through current research on the history of Jimmie Winkfield, Isaac Burns Murphy, and other black jockeys who saw their careers dwindle through racism and the rise of Jim Crow in the United States.[37] In a study on African American jockeys, Edward Hotaling (1999) details the waning influence of black jockeys in the early years of the twentieth century, especially at northern racetracks, citing racism within athletics in the early part of the twentieth century and threats to the sport from anti-gambling reformers. By the 1920s African American riders had almost disappeared from thoroughbred racetracks all over the United States (Hotaling 1999, 328). Experiencing an increasingly hostile environment, famed jockeys such as Jimmy Winkfield left the United States to ride on the European continent.

Hotaling attributes the twentieth century rise in racism to the corresponding rise of

prize money, or purses. As the sport became profitable, black jockeys were increasingly eased out of the limelight (Hotaling 1999, 328). Hotaling reminds us that as far north as Saratoga, the recreation center that serves the backstretch population (and was once known as the "Jockey Y") constructed a swimming pool facility in 1928 with an underwater wall in the pool to separate African American jockeys from their white counterparts. He writes, "Unlike other sports and other fields, however, racing could not have sustained a separate black 'league,' with black farms, black owners, black tracks, black jockeys. It had to be interracial or not. It chose 'Not'" (Hotaling 1999, 332). By 1975, there were no more than ten black jockeys riding the race circuit.

The decline of African Americans in all positions in the thoroughbred racing industry has been apparent in the years after the turn of the twenty-first century, as Latino workers now make up the largest population of stable hands—hot-walkers and grooms. Often originating in rural areas of Latin and South America, they are willing to work the long hours required for low pay.[38] Latinos are less frequently found as assistant trainers and trainers, but they dominate in the role of jockey. In 2013, 60 percent of jockeys were Latino, and, nine of the ten top-earning jockeys were from South America (McKenzie 2013). Mexicans make up the largest group of Spanish-speaking workers,

although individuals can be found from Puerto Rico, Costa Rica, Argentina, Peru, and other Spanish-speaking countries in South America.

The rise in immigrant and migrant labor within the track world has perpetuated an entrenched system in which mobility into other positions with higher prestige is difficult. Higher-status positions continue to be barred due to long-standing racism in the racing world. In addition, issues of economic mobility and fair wages are compounded due to language difficulties and the willingness by immigrant laborers to settle for lower wages. Trainers independently hire their own grooms and because each trainer works as an independent agent, job security among stable workers is effectively nonexistent. The groom who complains about unfair conditions can quickly find him- or herself without a job. There always will be someone ready to take the vacant position.

With the rising numbers of Latino workers, there is mobility between home country and the United States, as well as a certain amount of "chain migration," where family members recruit other members of their family for positions at the racetrack. In several cases, cousins or siblings might be found at the racetrack holding positions with different trainers. Those already employed assist family members when a vacancy is noted. This trend toward the involvement of entire families is not just within

the lower-skilled positions, but permeates the entire racing world. Similar to the world of the circus, where family members are involved throughout their lives and find their niche within the established structure, members of racing families tend to remain within the racetrack world, seeking out roles and positions to suit their needs.

Latino workers began to enter the backstretch beginning in the late 1960s and early 1970s, and today this population makes up the majority of workers on the backside. Receiving H-2 visas as temporary workers, Latino workers who have entered this country from Mexico and elsewhere in South America have done so through a United States government–supported program that sanctions the entry of temporary workers for agricultural labor. Increasingly since 1988, H-2 visas have been used for other sorts of seasonal labor beyond purely agricultural field labor, including grooms and hot-walkers in the horse racing industry (Griffith 2007). Beginning in the 1980s, and increasingly in the 1990s, Mexican stable workers in the thoroughbred horse industry found employment through the H-2B guest-worker program for non-agricultural labor (Griffith 2007), replacing earlier occupational workers, including those representing African American communities. In a perpetuation of historic relationships between horse owner, trainer, and those who work at the lowest levels, Latino workers under the H-2B guest worker program find themselves indebted to a trainer. In effect, they are legally bound to their employer under the conditions of the H-2B visa (Griffith 2007). One trainer remarked, "I don't know if we could survive as an industry without the Spanish people now. It's amazing. It is amazing because they can survive on so little. We have people living in tackrooms. They have families here with kids. It's just amazing."[39]

As pointed out by David Griffith, in his work on Jamaican and Mexican guest-worker programs, the hidden cost of this exploited labor pool is the numbers of women and children left behind in their home countries who receive remittances from their spouses and fathers but suffer for the rupture of the fabric of familial connections (Griffith 2007). Groom Juan Salcido Sanchez reflected on his separation from family as a result of his work as a groom: "We spend a lot of time here. I got my family in Mexico. I got three kids and sometimes I really miss a lot, my family. But this is just, for us it's part of the life."[40]

As rural areas of the United States have turned to other occupations besides farming, and the use of the horse as working animal within a ranching environment has been replaced by all-terrain and other motorized vehicles, horsemanship skills are ceasing to be honed in America. As a result, thoroughbred horse owners point to a scarcity of skilled

horsemen to work at the racetracks. Countries such as Mexico and Guatemala have continued to support a vaquero or "cowboy culture," and workers from South American countries are more likely to bring already competent skills for working with horses (Lavigne 2009). Some horsemen point to Mexican workers as being particularly skilled, saying, "They have a love for these horses. And they make good horsemen. That they do."[41]

Other sources of Latino workers include those who have experienced working at racetracks in Mexico City and Puerto Rico. Famed jockey Angel Cordero learned to ride from his father and grandfather, both of whom were involved with the racetrack as riders and trainers in Puerto Rico.[42] Assistant trainer Saul Castellanos spoke of the importance of family recommendations when finding work at the thoroughbred racetrack: "Before it was really difficult to get in here because they all family. My brother bring me, and I bring my other brother, and my brother bring his friends. That's how it used to work."[43]

Groom Juan Salcido Sanchez works with two of his many brothers. To date, many of his friends and neighbors from his hometown in Mexico have become part of the workforce of the American racetracks. Says Sanchez:

Every time that I get chance I bring someone from my country. From my place. The last year I brought two of my brothers. So, the first thing that I say is, "Don't be scared about the horses. The horses don't going to do nothing wrong." These horses know everything about the job like us. The horse knows that I'm going to be inside the stall and the things that I have to do. So that is the first thing that I say, "Don't be a-scared." Sometimes the horses are bigger and wild and when you saw the horses you are, "What is going to happen?" They are not a bad animal. Most of the horses are real nice. So that is the thing that I say, "Don't be a-scared." And then I try to teach them how to work with the horses, step by step. Easy. That is the first thing.[44]

While many people mentor friends, neighbors, and family members in their jobs at the racetrack, assistant trainer Saul Castellanos was not afforded that opportunity. Introduced to the racetrack by his older brother, Saul was thrown into an unfamiliar country and unfamiliar job to cope on his own:

I wish in my time, somebody can come and told me. "Listen, Saul, do this way. Don't do this. If you want to be a good worker, do this way." Nobody was saying that to me. My brother bring me here for spring break and he said, "OK, this is your job. Good luck." That was in Chicago, back

in Chicago. He goes, "OK this is your job, and I got to go to Kentucky tomorrow." So I was living with somebody I don't even know. Never see in my life, for two months. It was funny. I [could] hardly speak English. I ate chili and beans for a couple of months because that was only thing I could say. . . . I was twenty-two . . .[45]

Saul's journey and tenure at the racetrack is not typical. While many Latino workers stay in positions of less authority such as groom, Saul has advanced to the role of assistant trainer, a mid-level manager who is in charge of a portion of his employer's horses. As an assistant trainer to a large stable, Castellanos is in charge of overseeing the workers and the horse care for approximately thirty horses. He views himself as an important role model for other Latino workers at the racetrack, including the many grooms who work under his supervision.

A barn like this, of people. When you have people like people like I got, you really don't need an assistant. They know what to do. . . . To make people do things. If you say "please" they do it for you. They feel bad because you say "please" and "thank you." And they go, "ooh, he asked me for please so I have to do it." . . . They make my job a lot easy. A lot easy.

Everybody [started as a hot-walker]. I've been there. Definitely . . . I was a hot-walker at one point like these people. I was cleaning stalls at one point. I was sleeping in the tack room in front of my horses at one point. I was getting the truck from here to Florida, twenty-four hours in the truck with my horses, making sure my horses are OK. A lot of people say you sleep in truck. You really don't sleep in the truck. I mean, been there. Like I said, I'm proud of being here right now, of being an assistant.[46]

Similar to the "shop-floor" culture outlined by Gary Alan Fine (2006), the "small group" in this instance is the stable area of one trainer. Particularly for Latino workers, the stable creates the small group that is the "site of action" within the backstretch environment. Within any particular stable, workers develop their identities. Similar to Fine's office workers, stable workers within a barn construct an idioculture, "a system of knowledge, beliefs, behaviors and customs shared by the group," and distinct from other groups (Fine 2006). The working environment of each stable within the thoroughbred racetrack has its own "micro-culture," which is heavily influenced by the trainer, how he structures the training environment for the horses, and his or her treatment of his workers. Saul Castellanos prides himself on

the supportive environment within the stables he oversees: "We make a family there. Every time I hire somebody I feel like I make home and they stay here. . . . You make friends here. You make everybody like family here. People from different countries . . . people that work for me right now—there are people from Guatemala, Mexico, Argentina, El Salvador. But we all work together, we're one family. We don't even care where you're from."[47]

A lack of promotion is believed to be one of the factors contributing to the dearth of African American trainers since the 1970s and the current situation of only a few Latino workers in higher-level positions. Without seeing that there is a future to advance in the horse racing industry, ambitious track workers go elsewhere (Lavigne 2009). Those wishing to advance often find their efforts unrecognized by those most able to affect a change. One aspiring trainer outlined the situation in this way:

If you look at the sport today, how many African American women do you see training horses? You got women trainers but it's very difficult for them also. I'm not going to play the race card. I know I'm going to be realistic. I went to a lot of owners and they looked at me like I was crazy and tried to steer me in other directions. It's hard for women period in thoroughbred horse racing being the trainer but especially African American women. . . . You have a few [African American trainers]. You only have like maybe two more, maybe three more. You're locked out. You're locked out because an owner— a wealthy owner—they want someone blond, blue-eyed person in the paddock. They don't want a darker person representing them. It's just that simple. I'm going to be honest with you. You don't look good next to them in the paddock as far as they're concerned. . . . I have heard owners say it. They don't want no [hesitation] African American, Hispanic . . . They don't look good next to them in the paddock. I've heard them say it.[48]

As described by David Griffith in his work on guest-workers, those working on temporary H-2B visas create, and become entwined in, networks of Latinos throughout America. They also enter into "total institutions" that have been created around the guest worker program and that can control workers' space and housing through providing lodging and through regimenting their lives (Griffith 2007). Low wages and long hours, as well as a lack of clear opportunity for advancement, can provide ample opportunity for loneliness and despair. Because of a lack of mobility, and the unending regimen of horse care, workers on the backstretch can fall prey to the use of

drugs and alcohol, and the ready availability of betting on the races is an enticement to gambling. The use of alcohol and the loss of wages through gambling is a threat to stability and to friendship networks.

The wages provided at the racetrack are far above wages for unskilled work in Mexico. Workers typically send portions of their salaries home to family members, often spouses and children, to assist them with their lives in Mexico. While the scale is low by standards in the United States, as much of the work is for minimum wage, and the hours often exceed an eight-hour day, for those coming from Central and South American countries the newfound wealth is intoxicating. Juan Salcido Sanchez ruminated on the difficulties faced by Mexican racetrack workers who are new to the life of a temporary agricultural worker:

> *I miss my family a lot and it's not easy to be here for one year and a half, one year and nine months. It's just the things I have to do. . . . The first couple of years, I was like a teenager, I enjoyed about everything. Now I try to save a lot The first two or three years I didn't save anything because I got the things I never had it. I got the money. I got the car. . . . It's just part of the life.*
>
> *I lose a lot of friends here. Real nice friends. They were really nice people in Mexico. . . . It's easy to get here all the things. Some people never came back. I got some really nice friends we came together here and they are never going to come back . . . they got addicted to drugs and alcohol because they got the money they never had in Mexico. And they lose their head . . .[49]*

While the hours are long and compensation is low, many workers in the backstretch typically experience a large amount of satisfaction in their work. There is a feeling of camaraderie among stable workers and the web of personal connections extends beyond the occupational environment and into the social realm. Satisfaction in work has been attributed to the opportunity to successfully integrate work and leisure.[50] Within the world of the backstretch, one's work environment may also define family affiliations as well as one's social life. Saratoga Springs, for example, has certain bars and restaurants that are known to be frequented by racetrackers, so that non-working hours can be spent within the company of one's occupational peers.

Backstretch workers, such as Sanchez, experience satisfaction in their work and express sustained passion for the work that they do. "This job has everything. It is easy. It is hard. And you can get excited. It's very passionate. . . . Sometimes when I get a day off—usually I get

up at 4:30 in the morning So I get up at 5:00 or 5:30, and I go to the track and see the horses training. Because that's what I like to do."[51]

Horse trainers and stable workers experience an intense one-on-one relationship with racehorses and the problem-solving aspects of training. Said Oran Trahan:

This past winter was the first time since 1967, since I've been doing it on a professional level. The first time we had just a few horses in training and they were tired, sore. . . . I have a small farm and we rested them in the winter. And this was the first time in my life that I've been doing this that I'd get up in the morning and I had nothing to do. It was a terrible feeling. After about sixty days I got back into it. It's a way of life.[52]

Former trainer A.J. Credeur says this: "Once you get that racehorse element in your blood, you can't get rid of it. It's there for life. You're always going to have the passion for these horses. Because it takes passion. It takes a lot. You have to have a love of the game to be in it because if you don't, you won't be in it long. Because it consumes you."[53]

Epilogue

In 2014 New York State, under Governor Andrew Cuomo, approved casino gambling and a campaign began in non-metropolitan New York State to place four casinos: two to be located in the Catskills/Hudson Valley region, one for the Capital District/Saratoga region, and one for Central New York State. Already the home of nine racetracks, as well as five casinos run by Native American groups, New York is soon to be the home of four more non–Native American casinos in a bid by Governor Cuomo to provide economic development opportunities to economically depressed areas of the state (McKinley and Bagli 2014). Similar legislation is being proposed in Kentucky for the siting of seven casinos (Reid 2014). Citing competition from racetracks in Louisiana and Oklahoma that include casino-style slot machines at their racetracks, Texas is also hearing support for casino-style gambling from pro-gambling advocates that include the horse racing industry in that state (Olson 2014).

How this current rush for gambling proceeds to fill state treasuries will play out is anyone's guess. Also unknown is the ultimate effect on horse racing. Only time will tell. Thoughtfully, Oran Trahan offered this insight:

Racing is being supplemented by (and some people don't want to hear the word) but it's being supplemented by slot machines. What the slot machine has done in this state. It has rescued a dying industry—a big industry. Without the slots you'd probably have three or four tracks that would have gone belly-up. And this has happened all over the country. Slot machines are rescuing racing. And it's not a good thing. It's a band-aid approach. It's not bringing any more people into racing. It's bringing more people to the slots. And one of these days slots are going to wear out. . . . I look—probably not in my lifetime—but I can see where racing will go back to being what it was many years ago: the sport of kings. You can write that down. I know what I'm talking about. But we're having fun in the meantime . . .[1]

Notes

CHAPTER 1

1. Interview with Oran Trahan, Evangeline Training Center, Louisiana, 2012.

2. A "bush track" is a small racetrack. Most trainers are reluctant to rate racetracks in a hierarchical fashion, but those races at bush tracks are usually locally focused and attract horses from trainers in close geographic proximity.

3. Ronald Ardoin was born in June 1957 in Carencro, Louisiana. He got his start riding in match races in Carencro.

4. Interview with A.J. Credeur, Evangeline Training Center, Louisiana, 2012.

5. Interview with Cleveland Johnson, 2012.

6. Eddie Delahoussaye, born 1951, is from New Iberia, Louisiana.

7. Pat Day was inducted into the Hall of Fame as a jockey in 1991. Born Melvin "Pat" Day in 1953, he is originally from Colorado.

8. Mark Guidry was born in 1959 in Lafayette, Louisiana.

9. Kent Desormeaux was born 1970 in Maurice, Vermilion Parish, Louisiana. He is a horse racing Hall of Fame jockey who holds the US record for most races won in a single year in 1989.

10. Rob Alborado was born in 1973 in Lafayette, Louisiana. He got his start riding bush tracks in this area, winning his "maiden" at Evangeline Downs in 1990.

11. Shane Sellers was born in 1966 in Erath, Louisiana. His maiden race occurred at Evangeline Downs Race Track.

12. Interview with A.J. Credeur, Evangeline Training Center, Louisiana, 2012.

13. Interview with Cleveland Johnson, Belmont Race Track, 2012.

CHAPTER 2

1. Watchers are used to make sure that a racehorse eats without experiencing any difficulties.

2. Interview Saratoga, 1996.

3. Conversation with Mary Ann Avigood-Margotta, Saratoga, 1997.

4. Interview with Ellen Loblenz, Saratoga, 1998.

5. Interview with Calvin Kaintuck, Belmont Racetrack, 2012.

6. To "breeze" a horse is to ask it to run to its full potential, as in an actual race.

7. A "set list" is the riding order for that day's training.

8. Conversation with Lorna Chavez, exercise rider, Saratoga, 2012.

9. To "pony" a horse is to lead a horse while seated on another horse, for training purposes.

10. Because pavement provides a smooth surface, any gait abnormalities can be apparent when walking on a uniform surface. An abnormal gait can indicate pain or injury.

11. Interview with Ellen Loblenz, Saratoga, 1998.

12. Interview with Lorna Chavez, Saratoga, 2012.

13. A "gallop person" is another term for an exercise rider.

14. Interview with Bonnie Bernis, Saratoga, 1996.

15. Interview with Lorna Chavez, Saratoga Springs, 2012.

16. A "pony" is any horse at the track that is not racing. It can be a retired thoroughbred racehorse or any other horse breed.

17. The post parade is the procession of horses to the starting gate before a race.

CHAPTER 3

1. Interview with Ben Buhacevich, Tampa Bay, 2012.

2. Interview with Antoinette Brocklebank, Saratoga Springs.

3. Interview with Calvin Kaintuck, Belmont, 2012.

4. Interview with Oran Trahan, Evangeline Training Center, 2012.

5. Interview with groom, Palm Meadows Training Facility, Florida, 2013.

6. Interview with Ray Amato, Florida, 2012.

7. Interview with R. P., Tampa Bay, 2013.

8. The use of language has been noted by David Maurer in his study *The Argot of the Racetrack*, published by the American Dialect Society in 1951.

9. Interview with Robert Paterno, Tampa Bay, 2012.

10. Interview with Sarah Camele Arnold, Saratoga, 2013.

11. Interview with former trainer, Louisiana, 2012.

12. Interviews 2012.

13. Interview with R. P., Tampa Bay, 2012.

14. Interview with Oran Trahan, Evangeline Training Center, 2012.

15. A trainer's saddle towel is worn underneath the saddle and is a way for racetrack officials to identify horses by their trainers during training periods.

CHAPTER 4

1. A "pony" is any horse used around a racetrack for purposes other than racing. Maurer, David. *The Argot of the Racetrack.* Tuscaloosa: University of Alabama Press, 1951.

2. The paddock is the enclosure where horses are saddled. Maurer, *The Argot of the Racetrack.*

3. Interview with groom, Palm Meadows Training Facility, Florida, 2013.

4. Rosecrance applies Erving Goffman's idea of the "back region" or "backstage" that is hidden from public view, in his study *The Presentation of Self in Everyday Life*, 1959.

5. Interview with Jerry, Saratoga, 1996.

6. Interview with Jerry, Saratoga Springs, 1999.

7. In her sociological study of the racetrack, Carole Case has named the interacting in the paddock before a race as a ritual with specific roles and players.

8. Maurer, in *The Argot of the Racetrack*, defines the post parade as "the act of parading the horses in front of the stands before racing," the "post" being "the place from which horses begin a race."

9. Interview with Bill Boland, Saratoga, 1996.

10. See Harrah-Conforth, Jeanne. *The Landscape of Possibility: An Ethnography of the Kentucky Derby*. Indiana University: Ph.D. dissertation, 1992.

11. Victor Turner defines *communitas* as "that undifferentiated experience of communion" in his 1969 treatise, "Liminality and Communitas" in Turner, *The Ritual Process*. Chicago: Aldine.

12. Borrowing again from Turner, who writes of cultural performances as occurring in the "subjunctive tense." Turner, Victor. "Liminality and the Performative Genres." In John J. MacAloon, *Rite, Drama, Festival, Spectacle*. Philadelphia: ISHI, 1984, 20.

13. See Katherine Young, *Bodylore*. Knoxville: University of Tennessee Press, 1993; as well as Niko Besnier and Susan Brownell, "Sport, Modernity, and the Body," *Annual Review of Anthropology* 2012. "Bodylore," as a focus of folklore study, was an approach highlighted through a panel organized by Katherine Young for the 1989 American Folklore Society conference, held in Philadelphia. In a panel session, relationships to the corporeal body were examined by a number of scholars. This approach to perceiving the sensory aspects of cultural activity has been a subject of inquiry by those studying sport. Most recently, scholars are examining the ways that sport can be perceived as a cultural experience of the body in performance.

CHAPTER 5

1. For a series of articles on the horse racing industry and its practices, see the article "Mangled Horses, Maimed Jockeys," *New York Times*, March 24, 2012.

2. Interview with Dave Erb, 1997.

3. Interview with groom, 1996.

4. Interview with Dave Erb, 1997.

5. Interview with Oran Trahan, Evangeline Training Center, 2012.

6. Interview with A.J. Credeur, Evangeline Training Center, 2012.

7. Interview with Juan Salcido Sanchez, Florida, 2013.

8. Interview with Robert Paterno, Tampa Bay, 2012.

9. Interview with Jake Delhomme, Evangeline Training Facility, 2011.

10. According to eHow.com, Ichthammol is a "black drawing salve," home remedy used to treat skin ailments.

11. Interview with groom, Saratoga, 1996.

12. Interview with Angel Cordero, August 22, 1997.

13. In the backstretch, a farrier is referred to as a blacksmith.

14. Interview with Dave Erb, 1997.

15. Interview with Cleveland Johnson, Belmont Racetrack, June 2012.

16. Interview with Oran Trahan, Evangeline Training Center, 2012.

17. Interview with trainer, Saratoga Springs, August 2013.

18. Interview, Saratoga Springs, July 2013.

19. Interview, Evangeline Training Center, October 2012.

20. Interview with Lorna Chavez, Saratoga Springs, 2012.

21. Interview with exercise rider, Saratoga Springs, 2012.

22. Interview with Lorna Chavez, Saratoga Springs, 2012.

23. Interview with Lorna Chavez, Saratoga Springs, 2012.

24. Interview with Juan Salcido Sanchez, Florida, 2013.

CHAPTER 6

1. The Jockey Club was formed from the efforts of a group of wealthy men who began to organize races for their own enjoyment in 1894. Currently a tax-exempt organization, the Jockey Club continues to maintain close ties to the regulation of the sport of racing. They maintain their offices in New York City and continue to oversee the US registry of thoroughbred horses.

2. The "handle" is the aggregate amount bet by all fans on a specific race.

3. Interview with A.J. Credeur, Evangeline Training Center, 2012.

4. Interview with George Arnold, Saratoga, 2013.

5. Interview, Saratoga, 2013.

6. Interview with Dave Erb.

7. Interview with groom, regarding trainers.

8. Interview with Angel Cordero, August 22, 1997.

9. Interview with Sarah Camele Arnold, Saratoga, 2013.

10. Interview with former jockey Tommy Luther, Saratoga, 1995.

11. Interview with William "Bill" Boland, 1994.

12. Interview with Ellen Loblenz, Saratoga, 2001. "Pancaking" means falling directly on top of the rider.

13. Interview with Ellen Loblenz, Saratoga, 2001.

14. Interview with Bonnie Bernis, Saratoga Springs, 1995.

15. Interview with Robert Paterno, Tampa Bay Downs, 2013.

16. Interview with Juan Salcido Sanchez, Florida, 2013.

17. "Ponying" refers to guiding a horse around the track to school it to racing. This is done with a mounted rider on a "pony." There may or may not be a rider on the horse being schooled.

18. Interview with Robert Paterno, Tampa Bay Downs, February 2012.

19. Interview with Tommy and Helen Luther, Saratoga Springs, August 1995.

20. Interview with Ellen Loblenz, Saratoga Springs, 1995.

21. Interview with Calvin Kaintuck, Belmont Race track, 2012

22. Interview with Lorna Chavez, Saratoga Springs, 2012.

23. Interview with Ellen Loblenz, Saratoga Springs, 1995.

24. Interview with Calvin Kaintuck, Belmont Racetrack, 2012.

25. Interview with Ellen Loblenz, Saratoga Springs, 1995.

26. Interview with Sarah Camele Arnold, Saratoga Springs, 2013.

27. Interview with Ben Buhacevich, Tampa Bay Downs, 2012.

CHAPTER 7

1. See Archie Green, "Industrial Lore: A Bibliographic Semantic Query," *Western Folklore* (1978), for a discussion of labor folklore and folklore scholarship.

2. Archie Green draws attention to the American Dialect Society's interest in occupational languages. He mentions that many of the early members of the American Folklore Society were also members of the American Dialect Society. See Green, "Industrial Lore: A Bibliographic Semantic Query."

3. Interview with Ray Sibille, Evangeline Training Center, 2013.

4. According to the AAEP, there are two categories of horses that compete within thoroughbred racing. The sport's top-level competitors, representing approximately 30 percent of the total racing population, compete in stakes and allowance races. The remainder (the majority of horses) compete in condition or claiming races. Claiming races are used as a way to sell a horse who is underperforming, as a condition of the race is the sale to an interested buyer of the winning horse.

5. According to *The Dictionary of American Slang*, the term "maiden" refers to a horse that has never run a race. To "break a maiden" refers to a horse's first win. The word has its origin in the Old English *maegden*. In the case of a racehorse, "maiden" references the situation of being "untried." While the term is most frequently used in today's parlance in reference to a woman, the original meaning of the word also had relevance to knights, soldiers, or weapons.

6. Referring to the inability to race if one's weight is too high.

7. Interview with Bill Boland, Saratoga Springs, 1995.

8. Interview with Forrest Kaelin, Tampa Bay, 2012.

CHAPTER 8

1. Interview with Lorna Chavez, Saratoga Springs, 2012.

2. The speaker here wanted to make the point that hardships in the backstretch are shared equally with all the stable workers, regardless of place of origin.

3. Interview with S.C., Saratoga Springs, 2012.

4. Interview, Saratoga Springs, 2012.

5. Match races, when one famed horse competes with another famed horse, is an important part of the racetrack tradition. Many southern riders got their start riding match races at the community level. Throughout the history of racing in the eighteenth, nineteenth, and early twentieth centuries, match races were common between regional champions.

6. Col. Philip T. Chinn (1874–1962) was a Kentucky horse breeder and trainer who was known for his skills as a raconteur. Described as being "emotionally impervious to the ebb and flow of monetary fortune," Chinn was known to be a frequent lender of money to others (Kentucky Historical Marker N 38° 02.509 W 084° 29.401).

7. Interview with Tommy and Helen Luther, Saratoga Springs, NY, 1995.

8. It is unknown what "secrets" are referenced. It could refer to training practices, or to interventions to try to make a horse perform better, many of which are illegal and could cause sanctions if caught.

9. Interview with Ray Sibille, Evangeline Training Center, October 2012.

10. A reference to winning his first race in 1969, and thereby losing his status as an apprentice.

11. Interview with Ray Sibille, Evangeline Training Center, October 2012.

12. Interview with Forrest Kaelin, Tampa Bay, 2012.

13. Born 1933, William "Bill" Boland is a Hall of Fame jockey from Corpus Christi, Texas.

14. Max Hirsch (1880–1969), a Hall of Fame trainer based in Fredericksburg, Texas, was one of the most successful trainers in thoroughbred history.

15. Interview with Bill Boland, Saratoga Springs, 1994.

16. Interview with Angel Cordero, Saratoga Springs, 1994.

17. Interview with Bill Boland, Saratoga Springs, 1994.

18. Interview with Ray Sibille, Evangeline Training Center, October 2012.

19. Interview with Bill Boland, Saratoga Springs, 1994.

20. H. Alan Jerkens, born 1929 in Islip, Long Island, is a Thoroughbred Hall of Fame trainer. In several interviews, Jerkens was lauded for his advocacy toward individuals wishing to further their careers in racing.

21. Interview with Lorna Chavez, Saratoga, 2012.

22. Interview with Ray Sibille, Evangeline Training Center, October 2012.

23. Interview with Tommy and Helen Luther, August 3, 1995.

24. Interview with Bill Boland, 1999.

25. Interview with Bonnie Bernis, Saratoga, 1996.

26. Interview with Lorna Chavez, Saratoga, 2012.

27. Interview with A.J. Credeur, Evangeline Training Center, 2012.

28. A reference to jockey Rosie Napravnik. Riding as a licensed jockey since 2005, Rosie Napravnik became the first woman to ride in all Triple Crown Races (Preakness, Belmont Stakes, and the Kentucky Derby) in 2013.

29. Interview with Lorna Chavez, Saratoga, 2012.

30. Interview with Bill Boland, Saratoga, 1996. Boland is referring to the riding of Barbara Jo Rubin in January 1969 at Tropical Park in Miami, Florida. Pressure from male jockeys caused her to withdraw from the race. She went to the Bahamas, where she won her first race, and then returned to the United States to become the first woman to win a US betting (parimutuel) race—that is, racing at its highest level nationally—which she won in West Virginia on February 18, 1969. Diane Crump is attributed to breaking the gender barrier for being the first woman to ride in a parimutuel race, at Hialeah Park.

31. David Erb is a retired jockey and trainer who got his start as a jockey in 1938.

32. Born in 1964, Rice is the daughter of a horse trainer who had her first win in 1988 and has total earnings in the millions.

33. I am referring particularly to racing's references to the "maiden."

34. Interview with Jerry Delhomme, Louisiana, 2012.

35. Interview with Essie Sitgrave for the Kentucky Oral History Project, 1995.

36. Interview with Cleveland Johnson, Belmont Racetrack, 2013.

37. See Hotaling, *The Great Black Jockeys*; Rhoden, *Forty Million Dollar Slaves*; and Drape, *Black Maestro*.

38. In 2012, standard pay for a groom was $10.50/hour for a forty-eight-hour week. Overtime pay was $15/hour. Pay and worker's protections vary from state to state, depending on the state's labor laws and the trainers' scales. Riders get paid about $15 for each ride, $20 for a difficult horse. At the top of the scale is $700–$1,000/week for a salaried rider.

39. Interview with Jerry Delhomme, Louisiana, 2012.

40. Interview with Juan Salcido Sanchez, Palm Meadows, 2012.

41. Interview with A.J. Credeur, Evangeline Training Center, 2012.

42. Interview with Angel Cordero, Saratoga Springs, 1995.

43. Interview with Saul Castellanos.

44. Interview with Juan Salcido Sanchez.

45. Interview with Saul Castellanos.

46. Interview with Saul Castellanos.

47. Interview with Saul Castellanos.

48. Interview with Saudi Burton, Saratoga Springs, September 2013.

49. Interview with Juan Salcido Sanchez.

50. Michael J. Bell writes about this feeling of satisfaction as "making art work."

51. Interview with Juan Salcido Sanchez.

52. Interview with Oran Trahan, Evangeline Training Center, October 2012.

53. Interview with A.J. Credeur, Evangeline Training Center, October 2012.

EPILOGUE

1. Interview with Oran Trahan, Evangeline Training Center, October 2012.

Works Cited

AAEP Racing Task Force. *Putting the Horse First: Veterinary Recommendations for the Safety and Welfare of the Thoroughbred Racehorse.* White paper. Lexington: American Association of Equine Practitioners, 2008.

Abrahams, Roger. *Everyday Life.* Philadelphia: University of Pennsylvania Press, 2013.

Alfange, Dean. *A Glossary of Racing Terms.* New York State Racing and Wagering Board, n.d.

Allen, Samuel K. "Workers' Compensation Mechanism for Jockeys: A Report Prepared for the Horseman's Benevolent Protective Association." December 2003. www.hbpa .org/resources/MechanismforJockeys.pdf (accessed May 17, 2014).

Alpert, E. "Dealing with Danger: The Normalization of Risk in Cycling." *International Review for the Sociology of Sport* 34 (1999): 157–71.

Armstead, Myra B. Young. *"Lord, Please Don't Take Me in August": African Americans in Newport and Saratoga Springs 1870–1930.* Chicago: University of Illinois Press, 1999.

Atkinson, Ted, with Lucy Freeman. *All the Way!* Paxton Slade, n.d.

Barker, Jeff. "Preakness 2013: Jockeys Call for Increased Disability Insurance." *Baltimore Sun.* May 13, 2013. http:// articles.baltimoresun.com/2013-05-13/business/bs-bz -jockey-insurance-20130513_1_gary-birzer-five-jockeys -disability-insurance (accessed May 17, 2014).

———. "Preakness 2014: Little Luck when Jockeys Get Hurt." *Baltimore Sun.* May 15, 2014. http://articles.baltimore sun.com/2014-05-15/sports/bs-sp-preakness-jockey -injuries-20140515_1_the-jockeys-gary-birzer-jose-ville gas (accessed May 17, 2014).

Besnier, Niko, and Susan Brownell. "Sport, Modernity, and the Body," *Annual Review of Anthropology* (2012).

Bogdanich, Walt, Joe Drape, Dara L. Miles, and Griffin Palmer. "Mangled Horses, Maimed Jockeys." *New York Times*, March 24, 2012.

Brunvand, Jan. *The Study of American Folklore.* New York: Norton, 1978.

Burke, Kenneth. *A Rhetoric of Motives.* Berkeley: University of California Press, 1969.

Butler, Deborah, and Nickie Charles. "Exaggerated Femininity and Tortured Masculinity: Embodying Gender in the Horseracing Industry." *Sociological Review* (2012): 676–95.

Caillois, Roger. *Man, Play and Games.* Chicago: University of Illinois Press, trans. 1961.

Carmeli, Yoram. "An Outside and a Fool: Participant Observation in a British Circus." *Play and Culture* (1991): 305–21.

Case, Carole. "Argot Rules in Horseracing." *Urban Life* (1984): 271.

———. *Down the Backstretch.* Philadelphia: Temple University Press, 1991.

———. *The Right Blood: America's Aristocrats in Thoroughbred Racing.* New Brunswick: Rutgers University Press, 2001.

Chen, Lung Hung, Yun-Ci Yi, Mei-Yen Chen, and I-Wu Tung. "Alegría! Flow in Leisure and Life Satisfaction: The

Mediating Role of Event Satisfaction Using Data from an Acrobatics Show." *Social Indicators Research* (2010): 301–13.

Chong, Kevin. *My Year of the Racehorse: Falling in Love with the Sport of Kings.* Vancouver: Greystone Books, 2012.

Csikszentmihalyi, Mihalyi. *Beyond Boredom and Anxiety.* San Francisco: Jossey-Bass, 1975.

Cummings, G. Clark. "The Language of Horse Racing." *American Speech* (Duke University Press) 1955: 17–29.

da Col, Giovanni. "Natural Philosophies of Fortune—Luck, Vitality, and Uncontrolled Relatedness." *Social Analysis* (2012): 1–23.

Davidson, Scooter Toby, and Valerie Anthony. *Great Women in the Sport of Kings: America's Top Women Jockeys Tell Their Stories.* Syracuse: Syracuse University Press, 1999.

Dictionary of American Slang, The. n.d. "maiden." http://dictionary.reference.com/browse/maiden (accessed October 28, 2014).

Drape, Joe. *Black Maestro: The Epic Life of an American Legend.* New York: Harper Collins, 2006.

Farra, Ron. *Jockeying for Change.* Saratoga Springs: Ron Farra, 1998.

Ferraro, Gregory L. "The Corruption of Nobility: The Rise and Fall of Thoroughbred Racing in America." *North American Review* (1992): 4–8.

Fine, Gary Alan. "Shopfloor Cultures: The Idioculture of Production in Operational Meteorology." *Sociological Quarterly* (2006): 1–19.

———. "Justifying Work: Occupational Rhetorics as Resources in Restaurant Kitchens." *Administrative Science Quarterly* (March 1996): 90–115.

Freer, Jim. "Workers' Comp Plan Sought for Gulfstream." *Blood Horse*, September 12, 2013.

Frey, James H., and D. Stanley Eitzen. "Sport and Society." *Annual Review of Sociology* (1991): 503–22.

Gordon, Danielle. "Horse Racing's Ghetto." *Illinois Issues* (June 1995): 18–22.

Green, Archie. "Industrial Lore: A Bibliographic Semantic Inquiry." *Western Folklore* (1978): 213–44.

———. *Wobblies, Pile Butts, and Other Heroes: Laborlore Explorations.* Chicago: University of Illinois Press, 1993.

Greenhouse, Steven. "Racetrack Workers Aren't Paid Minimum Wage, State Agency Finds." *New York Times*, August 28, 2008: B3.

Griffith, David. *American Guestworkers: Jamaicans and Mexicans in the U.S. Labor Market.* Pennsylvania State University Press, 2007.

Gumperz, John. "Types of Linguistic Communities." *Anthropological Linguistics* (1962): 28–40.

Harrah-Conforth, Jeanne. *The Landscape of Possibility: An Ethnography of the Kentucky Derby.* Bloomington: University of Indiana Press, 1992.

Helmer, James. "The Horse in the Backstretch." *Qualitative Sociology* vol. 14, no. 2 (1991): 195.

Hildebrandt, Louis F., Jr. *Hurricana: Thoroughbred Dynasty, Amsterdam Landmark.* Amsterdam: Louis Hildebrandt Jr., 2009.

Hildebrandt, Louis. *Riders Up.* Sierra Solutions ADK, 2003.

Hillenbrand, Laura. *Seabiscuit: An American Legend.* New York: Random House, 2001.

Hotaling, Edward. *The Great Black Jockeys.* Rocklin, CA: Prima Publishing, 1999.

———. *They're Off!* Syracuse: Syracuse University Press, 1995.

Itzkowitz, David. "Victorian Bookmakers and Their Customers." *Victorian Studies* (Autumn 1988): 6–30.

Jackson, Bruce. *The Story Is True: The Art and Meaning of Telling Stories.* Philadelphia: Temple University Press, 2007.

Jackson, Susan. "Toward a Conceptual Understanding of the Flow Experience in Elite Athletics." *Research Quarterly for Exercise and Sport* (1996): 76–90.

Jackson, Susan, and Herbert W. Marsh. "Development and Validation of a Scale to Measure Optimum Performance: The Flow State Scale." *Journal of Sport and Exercise Psychology* (1996): 17–35.

Jockey Club of New York. *Rules of Racing.* New York: O'Brien and Son, 1895.

"Jockeys' Guild History." *Jockey's Guild.* 2014. http://www.jockeysguild.com/history.html (accessed April 22, 2014).

Jones, Christopher D., Steven J. Hollenhorst, Frank Perna, and Steve Selin. "Validation of the flow theory in an on-site whitewater kayaking setting." *Journal of Leisure Research* (2000): 247–61.

Jones, Stephanie K. "Rough Riding for Workers' Comp on the Racetrack." *Insurance Journal*, August 21, 2006.

Kirby, Julia. "Passion for Detail: A Conversation with Thoroughbred Trainer D. Wayne Lukas." *Business Week* (May 2004): 49–54.

Kniffen, Fred. "The American Agricultural Fair: The Pattern." *Annals of the Association of American Geographers* (1949): 264–82.

Kupfer, Barbara Stern. "A Presidential Patron of the Sport of Kings: Andrew Jackson." *Tennessee Historical Quarterly* (1970): 243–55.

Lavigne, Paula. "A fine fit: Horsemen and thoroughbreds." *ESPN*, September 15, 2009.

Lawrence, Elizabeth Atwood. *Rodeo: An Anthropologist Looks at the Wild and the Tame.* Chicago: University of Chicago Press, 1982.

LeBrun, W. Charlene. "Salt, Nails and Prayer: Horseracing and Superstition." *Louisiana Folklife Journal* (2009): 5–7.

Lockwood, Yvonne. "The Joy of Labor." *Western Folklore* (1984): 191–211.

Low, Setha. "Cultural Conservation of Space." In Mary Hufford, *Conserving Culture: A New Discourse on Heritage*, 66–77. Urbana: University of Illinois Press, 1994.

MacAloon, John J. "Olympic Games and the Theory of Spectacle in Modern Societies." In John J. MacAloon, *Rite, Drama, Festival, Spectacle: Rehearsals Toward a Theory of Cultural Performance.* Philadelphia: ISHI, 1984.

Maurer, David. *The Argot of the Racetrack.* Tuscaloosa: University of Alabama Press, 1951.

McCarl, Robert. "Occupational Folklife: A Theoretical Hypothesis." *Western Folklore* (1978): 145–60.

McDaniels, Pellom. *The Prince of Jockeys: The Life of Isaac Burns Murphy.* Lexington: University Press of Kentucky, 2013.

McGarr, Elizabeth. "A Jockey's Life, Stage 1." *Columbia News Service.* February 27, 2007. http://jscms.jrn.columbia.edu/cns/2007-02-27/mcgarr-bugboys.html#refwas (accessed May 17, 2014).

McGinnis, Joe. *The Big Horse.* New York: Simon and Schuster, 2004.

McGurrin, Martin, Vicki Abt, and James Smith. "Play or Pathology: A New Look at the Gambler and His World." In Brian Sutton-Smith and Diana Kelly-Byrne, *The Masks of Play*, 88–97. New York: Leisure Press, 1984.

McHale, Ellen. "An Ethnography of the Saratoga Racetrack." *Voices: Journal of New York Folklore* (2003): 7–11.

McKenzie, Sheena. "The Forgotten Godfathers of Black American Sport." *CNN.* February 22, 2013. http://edition.cnn.com/2013/02/22/sport/black-jockeys-horse-racing-sports-stars (accessed April 10, 2014).

McKinley, Jess, and Charles V. Bagli. "22 Companies Apply to Open 4 Casinos in New York State." *New York Times*, April 24, 2014. http://www.nytimes.com/2014/04/25/nyregion/nearly-two-dozen-groups-apply-for-a-new-york-casino-license.html?_r=0 (accessed May 28, 2014).

Moran, Paul. "Seeking Understanding and Tolerance." *ESPN Horse Racing*, March 19, 2012.

Olson, Corey. "Will Texas Bet on Casino Gambling?" *KRTH News Radio*, May 13, 2014. http://www.ktrh.com/articles/houston-news-121300/will-texas-bet-on-casino-gambling-12345849 (accessed May 28, 2014).

Raspa, Richard. "The Athlete, the Doctor, and the Patient." *Western Folklore* (2010): 332.

Ray, Margaret, and Paul W. Grimes. ""Jockeying for Position: Winnings and Gender Discrimination on the Thoroughbred Racetrack." *Social Science Quarterly* (1993): 46–61.

Reid, Rob. "Pro-Casino Groups Divided on Gambling Legislation." *Horse Racing Tipster.* March 8, 2014. http://www.ukhorseracingtipster.com/2014/03/pro-casino-groups-divided-on-gambling-legislation/ (accessed May 28, 2014).

Reinders, Rob. *The End of an Era: New Orleans 1850-1860.* New Orleans: Pelican, 1964.

Rhoden, William C. *Forty Million Dollar Slaves: The Rise, Fall, and Redemption of the Black Athlete.* New York: Crown, 2006.

Riess, Steven A. *The Sport of Kings and the Kings of Crime: Horse Racing, Politics and Organized Crime in New York 1865–1913.* Syracuse: Syracuse University Press, 2011.

Rosecrance, John. "The Invisible Horsemen: The Social World of the Backstretch." *Qualitative Sociology* vol. 8, no. 3 (Fall 1985): 248–65.

Schneider, Terri A., Ted M. Butryn, David M. Furst, and Matthew A. Masucci. "A Qualitative Examination of Risk Among Elite Adventure Racers." *Journal of Sport Behavior* 30, no. 3 (September 2007).

Shutika, Debra Lattanzi. *Beyond the Borderlands: Migration and Belonging in the United States and Mexico.* Berkeley: University of California Press, 2011.

Silverstein, M. "Contemporary Transformations of Local Linguistic Communities." *Annual Review of Anthropology* (1998): 401–26.

Smith, James F., and Vicki Abt. "Gambling as Play." *Annals of the Academy of Political and Social Science* (1984): 122–32.

Smith, Ronald W., and Frederick W. Preston. "Vocabularies of Motives for Gambling Behavior." *Sociological Perspectives*, 1984: 325-348.

Sparks, Randy. "Gentleman's Sport: Horse Racing in Antebellum Charleston." *South Carolina Historical Magazine* (1992): 15–30.

Stevens, Gary. *The Perfect Ride.* New York: Kensington, 2002.

Stoeltje, Beverly. "Power and the Ritual Genres: American Rodeo." *Western Folklore* (1993): 135–56.

Sutton-Smith, Brian, and Diana Kelly-Byrne. "Introduction to Adult Recreation and Games." In Brian Sutton-Smith and Diana Kelly-Byrne, *The Masks of Play.* New York: Leisure Press, 1984, 77.

Tangherini, Timothy. *Talking Trauma.* Jackson: University Press of Mississippi, 1998.

The Track at Saratoga: America's Grandest Racecourse. Directed by WMHT TV. 2013.

Tuan, Yi Fu. *Space and Place.* Minneapolis: University of Minnesota Press, 1977.

Turner, Victor. "Liminality and the Performative Genres." In MacAloon, John. *Rite, Drama, Festival, Spectacle: Rehearsals Toward A Theory of Cultural Performance.* Philadelphia: Institute for the Study of Human Issues, 1984.

———. *The Ritual Process: Structure and Anti-Structure.* Chicago: Aldine, 1969.

Veitch, Michael. *Foundations of Fame: Nineteenth Century Thoroughbred Racing in Saratoga Springs.* Saratoga Springs: Advantage Press, 2004.

Wall, Mary Jean. *How Kentucky Became Southern.* Lexington: University Press of Kentucky, 2010.

WikiHorseWorld.com. n.d. http://www.wikihorseworld.com/wiki/Ray_Sibille (accessed May 12, 2014).

Woodward, Kath. "Body Politics: Masculinities in Sport." In Ronald and Murali Balaji Jackson, *Global Masculinities and Manhood*, 202–21. Chicago: University of Illinois Press, 2011.

Young, Katherine. *Bodylore.* Knoxville: University of Tennessee Press, 1993.

Index